SECRET ROTHERHAM

Melvyn Jones &
Anthony Dodsworth

AMBERLEY

First published 2017

Amberley Publishing
The Hill, Stroud
Gloucestershire, GL5 4EP

www.amberley-books.com

Copyright © Melvyn Jones & Anthony Dodsworth, 2017

The right of Melvyn Jones & Anthony Dodsworth
to be identified as the Author of this work has been
asserted in accordance with the Copyrights, Designs
and Patents Act 1988.

ISBN 978 1 4456 6858 1 (print)
ISBN 978 1 4456 6859 8 (ebook)

All rights reserved. No part of this book may be
reprinted or reproduced or utilised in any form
or by any electronic, mechanical or other means,
now known or hereafter invented, including
photocopying and recording, or in any information
storage or retrieval system, without the permission
in writing from the Publishers.

British Library Cataloguing in Publication Data.
A catalogue record for this book is available from the
British Library.

Origination by Amberley Publishing.
Printed in Great Britain.

Contents

	Acknowledgements	4
	Introduction	5
1	Odd and Interesting Place Names	9
2	Monuments and Memorials	23
3	Made in Rotherham	40
4	Notable Residents and Visitors	56
5	On This Day...	71
6	Rotherham's Countryside	81
	Historical Timeline for Rotherham	94
	Bibliography	96

Acknowledgements

We would like to acknowledge Mexborough and District Heritage Society, Wayne Bennett and Michael Bentley for illustrations; Bill Lawrence, Gary Burton and Alex Fleming for help with regard to sources; and the late Bob Warburton for his drawings. We would also like to thank Chris Hamby for permission to photograph the interior of the Three Cranes Antiques Centre. We also acknowledge the assistance of staff at Rotherham Local Studies Library and Ordnance Survey for permission to use extracts from out of copyright OS maps. Last but not least we would like to thank our wives, Joan and Jane, for their proofreading and forbearance and Joan for scanning all the illustrations.

Introduction

Rotherham's origins lie beside an important river crossing on the River Don, below its confluence with the River Rother. The town still has one of only four surviving bridge chapels in the country. The old town grew up on the eastern bank of the river where a low bluff provided a commanding site for All Saints Parish Church (now Rotherham Minster), rebuilt at the end of the Middle Ages in the Perpendicular style, and whose tall spire has dominated the town ever since.

Before industrialisation Rotherham was a prosperous market town, with its marketplace occupying a site south-west of the parish church. The compact medieval town grew up around the churchyard and marketplace, with extensions along Bridgegate, Westgate, Moorgate, Wellgate and Doncaster Gate.

Industrial development began in the mid-eighteenth century with the establishment of Walker Brothers' Foundry in 1745–46 to the west of the Don in Masbrough. The iron founding tradition established by the Walkers eventually gave birth to Rotherham's important railway engineering industry, its stove grate industry and ultimately its steel

Chapel on the Bridge.

Bridgegate.

industry, dominated by the Park Gate Iron & Steel Works and Steel, Peech & Tozer's Templeborough Steelworks. In its heyday heavy industry dominated the flat land of the floodplain of the River Don from Tinsley in the south to Parkgate in the north. At Parkgate, the sites of former steelworks and associated railway lands are now the home of out-of-town shopping developments.

With local government reorganisation in 1974, the county borough was expanded to become a metropolitan borough, bringing former West Riding settlements – urban, suburban and rural in character – within its boundaries. The metropolitan borough now stretches from Wath upon Dearne in the north to Harthill in the south, and from Thorpe Hesley in the west to Maltby in the east. By 2011 it had a population of more than a quarter of a million.

The selected secrets, old and new, revealed in this volume provide a comprehensive record of many centuries of physical, economic and social change. They celebrate people and places and special historical events throughout the whole of the metropolitan borough.

The book is organised into six chapters. The first of these is concerned with the name-giving of the Anglo-Saxon, Viking and Norman settlers, including some very

The view northwards from Scholes towards Wentworth Church.

Rotherham Minster from the air.

odd street names. The second chapter investigates the origins of the monuments and memorials – ancient and modern – that pepper the landscape. The third chapter reveals the borough's fascinating industrial history. This is followed by a chapter on famous residents and visitors including members of the aristocracy, political figures, writers, musicians, diarists, entertainers and sports personalities. The penultimate chapter analyses some important, and sometimes dramatic, events that happened on a particular day in and around Rotherham, drawing on detailed local records. The final chapter celebrates the history of aspects of the borough's countryside: its former deer parks, landscaped parks, public parks and ancient woodland. Throughout, the text is accompanied by a wide variety of images, old and new.

We hope you agree that there is more to Rotherham than Daniel Defoe's rather dismissive remark that there was 'nothing of note, except a fine stone bridge over the Don'. Even then, nearly 300 years ago, the town and its surrounding area had a host of historical secrets waiting to be revealed. Now there are many more. Enjoy!

1. Odd and Interesting Place Names

Every time we walk down a street, drive to work or to the shops or hop on a bus we are surrounded by street names, and our everyday conversations are peppered with the names of Rotherham's suburbs and outlying villages. And yet many people don't give a second thought as to when they might have been coined or what they mean. Almost all of them are of Anglo-Saxon or Viking origin. Anglo-Saxons invaded and settled in this country from the fifth century, and settled in South Yorkshire in the early seventh century. They spoke what is called Old English, of which modern English is a much modified descendant. The word 'Viking' was the name given by the Anglo-Saxon population of England to the traders, raiders and then settlers from Scandinavia in the late eighth and ninth centuries. They spoke a language called Old Norse.

Up Hill and Down Dale

It is not surprising that our Saxon forbears, as they settled into the countryside that became Rotherham Metropolitan Borough, gave many names to the character of the land into which they were coming to settle. One of the most obvious things that they named as they began to note their surroundings were the hills, valleys, slopes and plains that they could see, or in or next to which they built their farms and villages. And so we get place names such as Thrybergh ('three hills'); Hoober ('high hill'); Hooton ('high farm', or later 'high village') as in Hooton Levitt, Hooton Roberts and Slade Hooton; and Canklow from the Old English *canc-hlaw* ('steep/rounded hill').

St John the Baptist Church, Hooton Roberts.

Canklow Bridge. John Guest, 1879.

As for valleys and lowlands, particularly interesting ones are Dalton Magna and Dalton Parva, which are derived from *dael-tun* ('dale' or 'valley farmstead', and later 'village'), *magna* and *parva* being Latin for 'great' and 'small'. Other low-lying areas are enshrined in the Old English place name Rawmarsh ('red marsh') and the Norse place names Holmes ('water meadow' or 'raised ground in a marsh') and Carr ('a wooded wetland'). Rawmarsh must not be named after the village site itself, which is up a low hill, but the surrounding territory that later became the parish of Rawmarsh, which stretches to the east across the floodplain of the River Don. The 'red' part of the name derives from the colouring of the soil due to the presence of ironstone below the surface. The presence of ironstone also gave rise to the local term 'okker watter' (ochre water) for a stream contaminated by exposure to ironstone, which is enshrined in the street name Ochre Dike Walk on the Kimberworth Park estate. As far as other river and stream names are concerned, Rother is believed to be a Celtic name that the Anglo-Saxons borrowed and is thought to mean 'chief river' or 'full river'. Why Rotherham is called Rotherham ('homestead beside the River Rother') and not Donham ('homestead beside the River Don' where the old town was located) is a mystery! 'Beck' in Firbeck and Sandbeck is the Old Norse name for a small stream. River crossings were also important to early settlers, and *wath* in Wath upon Dearne is the Old Norse word for a ford.

Ochre Dike Walk.

St James' Church, Church Street, Wath upon Dearne.

Some names get corrupted over time and it is necessary to look at the earliest spellings to get their proper meanings. Take, for example, the names Greasbrough and Brinsworth. At first glance the name Greasbrough looks just like other local names ending in 'brough', like Masbrough, Mexborough and Worsbrough, 'brough' meaning a fortification. But this is not so. In the Domesday Book of 1086 and in a succession of later medieval documents the spelling of the name is Gersbroc or Gresbroc, leading scholars to believe it means a gravelly or grassy brook. Similarly Brinsworth is a corruption of Brinsforth ('Bryni's ford'), which was a crossing of the River Rother.

DID YOU KNOW?
The name of the village of Wales is an Anglo-Saxon word – *walh* meaning 'foreigner' – that usually indicates an isolated Celtic settlement among a sea of new Anglo-Saxon settlers. It became the name of the country of Wales, where the greatest concentration of Celts lived. Other English place names with the same element include Walton, Walcott and Walshaw.

St John the Baptist Church, Wales.

Wildlife and Farm Animals

The early settlers were also aware of the wildlife of the areas in which they were settling, which is commemorated in three Old English names. The name Catcliffe refers to a steep riverbank on the River Rother where wild cats were prevalent, and the wood or woodland clearing where there were owls hooting is enshrined in the name Ulley (*ule-leah*). Harthill

Right: River Rother at Catcliffe.

Below: Scholes village in the early twentieth century.

is simply the hill frequented by harts (male red deer). The meaning of raven in Ravenfield is unclear. It could mean 'open country in an otherwise wooded area frequented by ravens' or raven could be someone's personal name.

Farm animals are named in Swinton ('pig farm'), and Hesley in Thorpe Hesley means 'a woodland clearing frequented by horses'. The farm called Hardwick between Thurcroft and Todwick simply means 'a livestock farm' (from *heorde*, which means 'herd' or 'flock') together with *wic*, which means 'farm', usually a dairy farm. Another interesting name connected with the farming of animals is the Old Norse name Scholes, which is not restricted to Rotherham but is distributed widely throughout the north of England, including other parts of South Yorkshire and neighbouring West Yorkshire. It is derived from the Old Norse word *skali*, which means a temporary settlement or 'shieling' where farmers took their livestock for summer grazing. In mountainous areas this meant taking flocks or herds from the valleys up the mountain slopes (the term used by geographers is vertical transhumance) but in other areas flocks were taken to outlying areas of a territory (horizontal transhumance). Significantly, Scholes village originally lay on the edge of the manor and later township of Kimberworth in the extensive ecclesiastical parish of Rotherham.

Woods and Trees, Woodland Clearings and Enclosures
By the time of the compiling of the Domesday Book, almost a thousand years ago, most of the wildwood that had covered large parts of England had been cleared and woodland only covered around 15 per cent of the land area in South Yorkshire. But there are still

The entrance to the village of Aughton.

Main Street, Wentworth early last century.

many names that tell us about the woodland cover, about farms and villages in the woods and the clearing of the woodland. Woodsetts means 'the settlement (seat) deep in the woods', Wentworth Woodhouse means 'a settlement in the woods near Wentworth', Treeton means 'the farmstead among the trees', Aughton means 'oak tree farm' and '*hyrst*' in Kilnhurst is 'a wooded hill'.

The most common Anglo-Saxon woodland clearing place name element in England is -*leah* as already noted in Ulley and Thorpe Hesley. It also occurs in Bramley ('woodland clearing overgrown with broom'), Harley ('clearing with a heap of stones') and Wickersley ('Vikar's woodland clearing'). The Old Norse equivalent is -*tveit* as in Guilthwaite. Once cleared the land was enclosed for sowing crops and pasturing livestock and enclosure names abound as in Kimberworth ('Cyneburg's enclosure'), Walkworth ('Walca's enclosure') and Wentworth ('Wintre's enclosure').

Viking Villages, Hamlets and Farms

The Viking invaders came in the late eighth and ninth centuries, settling among the Anglo-Saxons and bringing their language, which gave us much of our Yorkshire dialect. In settlement terms the most common Viking place names are those ending in -*by*, which indicates a main village and -*thorp*, which usually began life as a smaller settlement sometimes dependent upon a pre-existing -*by*. Some scholars believe they were small arable settlements as opposed to the earlier and bigger villages in which cattle and sheep farming were important. There are two -*by* settlements in Rotherham, Maltby and

Above: Hellaby Hall.

Left: The Norman doorway of Thorpe Salvin Church.

Hellaby, but five *thorps*: Thorpe Hesley, Thorpe Salvin, Bassingthorpe, Herringthorpe and Netherthorpe (a hamlet east of Thorpe Salvin).

Ginnels, Jennels, Snickets, Twitchells and Gates

The words ginnel, jennel, snicket and twitchell are used interchangeably in South Yorkshire. But there are subtle differences between them. A ginnel or jennel has to have a roof above it. It was usually a roofed passage built under the first-floor rooms of terraced houses, particularly back-to-backs. The ginnel led to the back door of superior terraced houses and to the front door of those back-to-backs, whose only door was in a communal

Narrow Twitchell.

Wellgate looking towards the Minster.

courtyard behind the row of houses. One authority believes that the word ginnel/jennel may be derived from the French word *chenelle*, meaning 'channel'.

A snicket or twitchell, on the other hand, was a narrow passageway, usually a shortcut and often between hedges or field walls, sometimes between buildings. But it was open to the sky above. A twitchell is not a commonly used term in Rotherham, but there is one narrow street that still bears the name: Narrow Twitchell (off Hollowgate).

Another name that may be confusing is the use of 'gate' in street names. There are street names including the element 'gate' in almost every town and city in West and South Yorkshire. Rotherham has Bridgegate, Moorgate, Doncaster Gate, Hollowgate and Wellgate. 'Gate' has nothing to do with gates. It is an Old Norse name brought to England by the Vikings. It simply means 'way', 'street', 'lane' or 'road'. Bridgegate means 'the street leading to and from the bridge' and Moorgate simply means 'the street leading to the moor' (i.e. the common). One lost street in Rotherham was called Fleshgate, from the Middle English word *flessche* meaning 'meat', so this was the street where the butchers had their stalls. The word 'gate' was also imported into the coal mining industry at an early date, the main roadway in a colliery being known locally as the main gate.

Roman Ridge, Caesar's Camp and Templeborough

The Roman Ridge is a linear earthwork in the form of a bank or a bank and ditch that stretches with breaks for almost 10 miles along the northern side of the Don Valley from Wincobank Hill in Sheffield to Mexborough. In one stretch it is in the form of two banks

The Roman Ridge (called Barber Balk) on the Kimberworth Park housing estate.

more than 800 metres apart. At one point it runs at the side of a road on the Kimberworth Park housing estate. It is at its most impressive where it runs in an unbroken sequence through the southern part of Wath Wood. Despite its name, it is not Roman. It was long thought to be prehistoric and possibly built at the same time as the forts at Wincobank and Scholes. More recently it has been suggested that it is of 'Dark Age' origin, built sometime between AD 450 and 600 after the collapse of the Roman Empire, possibly to defend the Celtic kingdom of Elmet (which stretched from Leeds to Sheffield) from the invading Anglo-Saxons.

The fort in Scholes Coppice has been called Caesar's Camp and Castle Holmes in the past. Despite the use of the name of a Roman emperor, like the Roman Ridge, this is not Roman. It is of Iron Age (700 BC–AD 43) origin. It is in the form of an earthen bank with an external ditch enclosing a flat area. An archaeological survey conducted in 1991 showed that the bank consisted of layers of stone over a compressed clay base. The discovery of a posthole suggested that the bank was surmounted by a timber palisade.

Templeborough, on the other hand, does mark a Roman site: a Roman fort, which was first established in AD 54. It was built of timber within a ditch and turf rampart. It was rebuilt in stone around AD 100. The fort was buried beneath a steelworks complex in 1916–17. The name given to the site of the fort, Templeborough, is thought to be a late sixteenth-century invention, although it is quite likely that it could have been

Caesar's Camp in Scholes Coppice.

Plan of Templeborough Roman fort.

called Brough (*burh,* meaning 'a fortification, earthwork or castle') by the local Old English-speaking population after the departure of the Romans as in the other local -*burh* name, Masbrough, which means 'fortification on the boundary'.

Law and Order and Political Decision-Making
There are three names of places in Rotherham Metropolitan Borough that take us back into a time when local political disputes and decision-making took place at an out of doors assembly. The names in question are Laughton en le Morthen, Brampton en

Laughton en le Morthen as depicted on Thomas Jefferys' map of 1771.

le Morthen and Morthen, all three places lying close together near the former mining village of Thurcroft (which itself did not exist as a village until coal mining began in the area at the end of the nineteenth century). And it is Morthen that is the significant name. It is believed that this is a corruption of the word *mor-thing*, which means an assembly or council (*thing*) on the moorland or common land (*mor*). All three places appear as early as the thirteenth century, when Morthen was spelled *Morthing* or *Morthyng*. Significantly, the Icelandic parliament – one of the oldest parliaments in the world – is called the Thing and the parliament in the Isle of Man, which was heavily settled by Vikings, is called the Tynwald (*thing wald*, meaning 'the parliament field').

> **DID YOU KNOW?**
> The name 'Roche' in Roche Abbey, which was founded in 1147, is the Old French word for rock and may simply be a translation of Stone, the name of the village just a short distance to the east.

Roche Abbey.

2. Monuments and Memorials

Monuments may be very substantial stone-built reminders of the past. Memorials often serve the same function but can be represented in a much greater variety of materials. In this chapter the history of Rotherham is brought into focus through looking at gravestones, stained-glass windows, effigies, monumental brasses, embossed scrolls, abandoned industrial buildings and stone-built follies. All serve as reminders of people, places and events from the past.

A Roman Soldier's Gravestone Originally from Templeborough

The Romans built a stone fort at Templeborough early in the second century AD as part of a network of fortifications linked by Roman roads. A settlement of retired soldiers grew beside the fort as well as an extensive burial ground. As pointed out in Chapter 1 the stone fort replaced an earlier fort of earth and wood. The site was excavated in 1916 because the land was needed to expand the Steel, Peech & Tozer's steelworks to meet the extra demand for steel in the First World War. In this excavation a gravestone dedicated to Cintusmus, a soldier in the 4th Cohort of Gauls, was uncovered. It can now be seen in Clifton Park

The gravestone of Cintusmus, a Roman soldier in Clifton Park Museum.

Verecunda Rufilia gravestone inscription in Clifton Park Museum.

Museum in Rotherham. His tombstone could be one of the earliest known to an auxiliary soldier in England. Tombstones for Roman soldiers have been found at a number of sites around the country – usually dating to the first or second centuries AD. Women were interred in Roman burial grounds as well as men and Verecunda Rufilia was one whose tombstone was also uncovered by archaeologists at Templeborough. The inscription for Verecunda is more informative than that for Cintusmus, and tells us that she was married to Exingus and was thirty-five years old. She was probably British as she is described as a citizen of the Dobunni, a Celtic tribe based in the area of Somerset and Gloucestershire. She was a most exceptional wife, which we know because her husband paid to have this inscribed on her gravestone! The BBC website describes her as one of the 'earliest known women in Britain'. The tombstone can also be seen in Clifton Park Museum.

The Medieval Stone Monument of a Civilian and Child in South Anston, *c.* 1345

This remarkable, and very unusual, medieval monument can be found at the back of St James' Church in South Anston. It consists of a male civilian with a small child at his elbow. An angel is shown reaching from above to touch the child. It is particularly rare to find a medieval monument that represents a man with a child on a stone effigy.

The stone effigy of a civilian in St James' Church, South Anston.

Amazingly, when this monument was included in Sir Nikolaus Pevsner's magisterial *Buildings of England – Yorkshire: The West Riding* it was described as a woman and child, but there is no doubt at all it is a man that is shown. The figure's long curling hair is crucial in identifying this as a male figure, as is his long hood and ankle-length garment. A married lady of this time would have been shown wearing a veil and with her feet hidden by a full-length garment. The long hanging and buttoned sleeves of the figure and the hip-level belt suggest a date in the 1340s. It is tempting to speculate that what is shown here is a father and daughter, and, considering the date, perhaps two of many local victims of the Black Death.

A Stained-Glass Memorial of William Reresby, Rector of Thrybergh, c. 1470

William Reresby was rector of St Leonard's Church, Thrybergh, from 1437–66. He is believed to have died in 1469 at the considerable age of eighty-six. He is shown in stained glass on the south side of the nave wearing a red gown and kneeling at an altar with his hands raised in prayer. Henry Johnson, a well-known antiquarian of the late seventeenth century, recorded the writing on the scroll shown beside the figure. It said,

William Reresby, *c.* 1470, in stained glass at St Leonard's Church, Thrybergh.

'God be merciful to me a sinner' and continued below, starting with the words 'Pray for the welfare of William Reresby, clerk, rector of that parish, who caused the work to be made as new...' This William is believed to have been both priest and squire of Thrybergh and the builder of the spire, which still survives. The Reresby family was associated with Thrybergh from at least 1328, when Sir Adam de Reresby was the owner, to the eighteenth century. They are said to have profited considerably from taking part in the Hundred Years War against France.

Medieval stained glass very rarely survives in South Yorkshire and what is found at Thrybergh must be among the best in the whole county. Having stated that, it should also be recognised that what remains today is only a tiny fragment of what was in place in medieval times. Despite the loss, what remains is a beautiful reminder of the colour and artistry originally found in England's medieval parish churches.

Anne Swift Represented on Two Monuments in the Rotherham Area

Anne Swift was the daughter of Robert Swift, who was sometimes referred to as 'The rich mercer of Rotherham'. When Robert died in 1561 he was represented on a brass

in the parish church of Rotherham with his wife and children. This monument can still be seen in the church today and one of the two female children shown on the brass is Anne. Around 3 miles east of All Saints, Rotherham, in St Leonard's Church in Thrybergh, a fine wall monument can be found to Lionel Reresby and his wife on the north wall of the chancel. They are shown with their sixteen children – seven boys and nine girls. Two of the children are shown as swaddled infants, suggesting they died young. Lionel's wife was Anne Swift and so she has the unusual distinction of being represented twice on monuments in the Rotherham area, but 3 miles apart. The Thrybergh monument probably dates to around 1587 when Anne died. Anne brought much-needed wealth to the Reresby family, long established in Thrybergh, and ironically some of her father's wealth was acquired by his dealing in land confiscated from the College of Jesus in Rotherham following the College's demise in the Reformation earlier in the sixteenth century.

Just as unusual is that Lionel and Anne's sixth daughter, Elizabeth, is also shown on two church monuments: the one in Thrybergh that was erected by Elizabeth for her parents, and the other in Harrington in Lincolnshire, where she is shown as the wife of Francis Copuldyck.

A brass in Rotherham Minster showing Robert Swift's family, including his daughter Anne, c. 1561

A monument for Lionel Reresby in St Leonard's Church, Thrybergh, including his wife Anne, *c.* 1587.

The Monument to Thomas Wentworth, 1st Earl of Strafford, in Wentworth's Old Church

The old church in Wentworth contains interesting monuments to four generations of the Wentworth family, the most important being to the 1st Earl of Strafford, who was executed in 1641. Ultimately he paid the penalty for being too loyal to Charles I. His monument was erected in 1685 by his son, the 2nd Earl of Strafford, and is an important reminder that church monuments may postdate (or even predate) the death of the person

Stone monument of Thomas Wentworth, 1st Earl of Strafford, *c.* 1685.

represented by some considerable time. The kneeling figure of Thomas in prayer is rather old-fashioned in style (a bust would have been much more fashionable) and his face is clearly copied from one of his contemporary portraits. After seeing it in 1756, Horace Walpole wrote to a friend: 'When I visited Strafford's tomb ... I was provoked to find a little mural cabinet with his figure three feet high kneeling. Instead of a stern bust (and his head would furnish a bust nobler than Bernini's Brutus), one is peeved to see a plaything that might have been bought at Chevenix's [the fashionable London shop for trifles]'. Walpole, who was something of an eighteenth-century style guru, was obviously not a fan!

The Eighteenth-Century Glass Kiln in Catcliffe, Rotherham
Rotherham has very few Grade I-listed buildings and perhaps the least well known is the eighteenth-century glass kiln at Catcliffe, which was built by William Fenney in 1740. Fenney had previously been the manager of a glassworks at Bolsterstone. It is the oldest surviving building of its type in Western Europe and there are only three similar kilns left in Britain – at Newcastle-on-Tyne, Stourbridge and Alloa. It was built on a hollow floor

Catcliffe glass kiln.

with a central furnace containing six crucibles of molten glass. The temperature in the kiln was controlled by closing doors or covering windows with large damp animal hides. It is known from the census that in 1861 around twenty-five people were employed at the 70-foot-high kiln making bottles, and some of them had moved from South Shields. Its ownership eventually passed to Henry Blunn, who continued glassmaking on the site to *c.* 1887. (The Blunn family also operated a glassworks on Glasshouse Lane near the pottery in Kilnhurst.) It opened briefly again in 1900 and is reported to have been used for prisoners of war during the First World War, as well as a children's canteen during the General Strike of 1926. In recent years funds have been provided to begin the restoration of the building.

Hoober Stand

Hoober Stand is surely one of Yorkshire's most famous monuments, and one with a fascinating history. The architect of the 90-foot-high pyramid was Henry Flitcroft, whose other work includes the east front of Wentworth House and Woburn Abbey. It is the only memorial in the country to commemorate the suppression of the Jacobite Rebellion in 1745 and the English victory at Culloden. It is also a very obvious statement of Thomas Watson-Wentworth's homage to his monarch, George II, who named him Marquis of Rockingham in 1746. Work started on the memorial in 1747 and the whole project was

completed in 1749. When Dr Richard Pococke, a visitor to the area, climbed the monument in 1750, he recorded that he could see York Minster – some 40 miles away – from the platform at the top. Pococke also mentioned a grotto cut out of rock beneath the Stand and 'prettily adorned as a hermitage'.

Struck by lightning in 1879, Hoober Stand was certainly not universally loved. An article in the *Sheffield Independent* in 1931 was headlined 'A Queer Memorial' and likened it to 'a gigantic pepper pot'. It continued, 'Visualise a three-cornered, squat, solid building

Hoober Stand.

View from Hoober Stand towards the mansion at Wentworth Woodhouse.

of surpassing ugliness'. The reporter went on to mention how for generations Hoober Stand had been the 'target of a day's outing'. He continued, 'I found quite a large number of the latest generation there when I went myself'. He was also struck by the amount of graffiti that covered 'nearly every available inch of its walls, scratched with initials and dates. I found them from as early as the end of the eighteenth century and as late as 1931' – another type of memorial! The following year Hoober Stand made news again when it was reported that the quiet roads near the Stand had attracted so many courting couples that residents in the district had complained to the police about their conduct.

DID YOU KNOW?
For well over 200 years Keppel's Column has been a notable feature on the Rotherham skyline. It is so-named after Admiral Keppel, a political ally of the 2nd Marquis of Rockingham, who was blamed by the government for the loss of a naval battle with the French and tried by court martial. He was acquitted. In the past doctors used to recommend that patients with chest complaints should climb to the top and breathe deeply. But it is also said that halfway up there was a stone table for laying out those who did not make it! Public access to Keppel's Column is now prohibited.

Keppel's Column today.

The Waterloo Kiln at Swinton Pottery
Rotherham is fortunate indeed to have the site of a world-famous pottery business within its boundaries, namely that of the Rockingham Pottery. Originally established in 1745, the pottery was re-financed by Earl Fitzwilliam in 1826 and produced china of outstanding quality in the late 1820s particularly. The kiln was built in 1815 and hence received the name of the most famous battle fought in that year. It originally contained a firing chamber for pottery and also dispersed hot air and fumes out of the roof opening.

Much less well known is the fact that for a number of years, at the end of the nineteenth and the beginning of the twentieth centuries, Waterloo Kiln was used as an isolation hospital for Swinton and Kilnhurst. Throughout the nineteenth century the number of smallpox outbreaks in England was generally in decline as a result of quite extensive vaccination programmes. As the danger seemed to be far less, some parents became complacent and no longer had their children protected. In January 1872 the local press announced that six fresh cases had occurred in Kilnhurst – the first for some time – and that it had at last got to Swinton, with cases at Bow Broom and Roman Terrace. The clerk of the Greasbrough Local Board suggested that the Swinton Old Pottery be used

for isolating fever cases from Greasbrough, Rawmarsh, Wath and Swinton. Whether this happened at that time is not certain, but in December 1887 the *Sheffield Independent* reported the formal opening of a building for the isolation of smallpox cases. Mr Haller, the surveyor to the board, provided an 'excellent hospital' for £160 in just seven days.

> The place selected for the infectious cases is a disused building on Swinton Common known in years past as the Swinton or Rockingham Pottery. It is some distance from any dwelling ... and provision has been made for 14 beds. The width of the building – which is circular in shape, towering to a point – is 30 feet and it had been partitioned off so as to form two separate chambers. A wooden structure has been erected adjoining the hospital containing accommodation for a nurse ... Boyle's patent three feet air-pumps are used in the wards to provide a continual current of air throughout the building.... The walls of the hospital are relieved with illuminated texts and other means of ornamentation kindly provided by ladies in the township.

The situation was certainly critical, as John Handley's (from Kilnhurst) death from smallpox at the age of thirty-five was announced in the same edition of the *Sheffield Independent*. It was said he caught the contagion while playing a game of football in Sheffield.

The Waterloo Kiln, Swinton.

The Cholera Burial Ground Memorial in East Dene

The nineteenth century saw the arrival of a new and devastating health threat to the people of Europe in the form of cholera. It spread into Europe from the East and was at first commonly known in Britain as Indian Cholera. The first major outbreak in England occurred in October 1831 and the first death from the disease was registered in Sunderland. The first deaths in Rotherham were recorded in 1832 and because of the threat of the dead bodies spreading the disease further, it was decided to bury them in an isolated spot beyond the built-up area of Rotherham. Initially the Board of Health contacted the Earl of Effingham for permission to use Boston Hillside for the burial of victims, and he offered a piece of land on the hillside free of charge. This arrangement was soon overturned as the town's inhabitants feared that water from springs on the hillside would be contaminated and perhaps spread the disease. Soon afterwards Robert Bentley of Bentley's Brewery, Westgate, offered a burial site at the edge of his farm in East Dene – some distance beyond Eastwood House. It was reported that the fear of cholera was so great that bodies were taken in wicker baskets to East Dene in the dead of night. In total, twenty-two victims were buried at East Dene in 1832. Another ten victims (the first to die) were buried in All Saints' Churchyard. Among the dead were James Carlton (who, at sixty-five, was the eldest), and Charlotte Lee, described as an infant. A further outbreak in 1849 saw another eight victims interred in the East Dene burial ground. In March 2008 Revd Hedley Richardson, the vicar of St James' in Clifton, conducted a special service at the burial ground following its renovation.

A recent view of the site of the cholera burial ground in East Dene. (*Inset*) The cholera monument as shown on the OS 25-inch map of 1922.

Steel, Peech & Tozer's Roll of Honour for the First World War

Most people are very familiar with the war memorials that grace most of our local towns and villages, but they are perhaps less aware of the existence of rolls of honour linked to the war service of employees of local companies, members of local clubs, and past pupils of schools. These usually list the name, rank and regiment of the people included, those who died in the war and possibly, if they were awarded any, medals for bravery. This one relates to the massive steelworks of Steel, Peech & Tozer's, which played a crucial role in the First World War and expanded considerably during the war itself. The company's production of steel for munitions is well known, but its production of millions of high-quality steel helmets that must have saved thousands and thousands of lives is often forgotten.

Many of the occupations linked to the steelworks were protected because of their national importance, but over 300 Steel, Peech & Tozer workers still joined up; eighty of these did not survive the war. One such employee was James Coad, who had originally lied about his age to join the army at sixteen in 1886. He had fought across the empire before leaving the army in 1907 and becoming a boiler fireman at the steelworks. When war was declared in 1914 he joined up immediately, despite being forty-four years of age and married with eight children. He was to die in Salonika in 1916. Similarly, Stephen Baker and his son Wilfred worked at SPT but enlisted in August 1914. They both joined the local Yorks and Lancs Regiment; within days of arriving at the Western Front in May 1915, both were killed at the Ypres Salient.

James Coad, a First World War soldier who worked at Steel, Peech & Tozer's.

First World War roll of honour for employees of Steel, Peech & Tozer's.

The Memorial for the Maltby Main Mining Disaster of July 1923

It took nearly a century for the Maltby Main mining disaster to be marked by a memorial, but in July 2015 a granite and black marble stone was unveiled that listed the names of the twenty-seven miners who died. The stone is located in Limekiln Lane, immediately above the site of the explosion.

It had been recognised for some time that the south-eastern part of the Yorkshire coalfield was particularly prone to firedamp and gob-fires, and before 1923 large explosions had caused very serious losses of life in the area – most notably at Warren

The new memorial for the men killed in the Maltby Main Mining Disaster of July 1923.

Vale in 1851 and 1874 and at Cadeby in 1912. A gob-fire had been raging for three weeks at Maltby Main before the disaster on 28 July, and, in fact, coal-getting had been suspended a week before and over 2,000 miners made idle. Around ten days before 28 July a rumour swept through the area that it had been decided to flood the pit to put out the fire, but this was denied by the officials. Small teams of miners, numbering around 100 men, were in the pit endeavouring to shut off the area of the fire from the rest of the mine, and, of these, twenty-seven were working at the far end of the gallery near the fire. The explosion seemed to have worked its way along the gallery and brought down such huge quantities of stone, coal and dirt that it proved impossible for the rescue parties, led by Sergeant Elliston of the Rotherham Central Rescue Station, to get through. The only body removed from the disaster was that of Original Renshaw (called Reg), aged thirty-eight, a road layer from Farquhar Road, Maltby. The remaining victims still lie entombed in the colliery today, in too dangerous an area to ever be recovered.

DID YOU KNOW?
On 23 February 1904 a terrible accident happened with the pit cage at Aldwarke Colliery at Parkgate and seven miners died as a result. A memorial to the men killed in the accident was placed in the Miners' Institute on Broad Street, Parkgate, but this is no longer accessible as the building is disused and council concerns over health and safety prevent entry.

3. Made in Rotherham

Rotherham has a very long and important industrial history. Local woods were managed for centuries to provide charcoal for foundries (*see* Chapter 6) and coal was mined for more than 200 years for conversion into coke for smelting iron and steel. Rotherham's manufacturing firms were at the forefront of the Industrial Revolution. They provided the metal that was used to hold up the dome of St Paul's Cathedral, the cannons for Nelson's HMS *Victory* at the Battle of Trafalgar, the plate for Brunel's pioneering steamship, the *Great Eastern*, metal for making Southwark Bridge across the Thames, kitchen ranges and fireplaces installed in the country's largest country houses and smallest cottages and screw-down taps, fire hydrants and oil pipeline valves throughout the world. The pottery and porcelain industries were also once important and the glass industry continues to make a considerable contribution.

Kirkstead Abbey Grange

Rotherham has the distinction of having the first documentary record of ironstone mining, ironmaking and iron forging in South Yorkshire. This relates to Kirkstead Abbey Grange at the top of Scholes Lane on Thorpe Common, the much altered descendant of the headquarters building of a grange built following a grant by the Norman lord Richard de Builli to the monks of Kirkstead Abbey in Lincolnshire in 1161. The grant allowed the monks to mine ironstone and make iron. They were allowed to build two furnaces, two forges, to collect deadwood from the common for fuel, to pasture their horses and oxen on the common and to build their headquarters and lay out a garden. As a result, it is

Stained-glass window in Sheffield Cathedral showing Kirkstead Abbey monks making iron.

Kirkstead Abbey Grange today.

not surprising that the surrounding area is peppered with small mounds marking the location of small bell pits where ironstone was mined. It is not clear how long the monks mined ironstone and manufactured iron on the site, but sixty-five years later in 1226 they were in dispute with the lord of the manor of Kimberworth, who had built a wall around part of the common to make a deer park and had barred access to the monks. The final agreement was that the abbot of Kirkstead Abbey's rights to pasture animals on the common, dig for ironstone, and marl and work forges in the new park, were annulled.

Beatson Clark's Glassworks

On a prime site beside the railway and canal in the centre of Rotherham is Beatson Clark's glassmaking factory. The firm is descended from a glassworks established on the site in 1751. The first member of the Beatson family associated with the works was John Beatson of Bentley Grange, who leased the works in 1783 in order to set up his son William and nephew Robert in business. John Graves Clark, who married William Beatson's daughter, became a partner in 1828. Early illustrations and photographs show the familiar tall brick-built cones that were once an integral part of any glassworks. The bottles and other glass containers were hand-blown at first, before semi-automatic and then fully

Above: Aerial view of Beatson Clark's glassworks.

Left: An old advertisement showing some of the products of Beatson Clark.

automatic machines were used. Every type of glass container has been made at the works for the food, drink and pharmaceutical industries: from eye baths and scent bottles to feeding bottles and bottles for the famous Izal disinfectant. Production still continues today, nearly 270 years after the establishment of glassmaking on the site.

The Walkers' Industrial Dynasty

Three brothers were the founding fathers of the Walker dynasty of Rotherham industrialists – Jonathan (1711–78), Samuel (1715–82) and Aaron (1718–77). Their business as ironfounders began in the village of Grenoside, 6 miles to the west of Rotherham, but they were drawn eastwards by the opening of the River Don Navigation in 1740. Samuel Walker moved to a new works close to the canal at Masbrough in 1746, and by 1760 all three brothers had moved to Rotherham. The firm then leased a large part of the Earl of Effingham's Holmes estate, where, eventually, their large works included blast furnaces, steel works, foundries and rolling mills.

The firm became expert cannon-makers and supplied Nelson's fleet that defeated Napoleon at the Battle of Trafalgar in 1805; their cannons can still be seen on HMS *Victory* at Portsmouth. There is also one on display outside Rotherham Town Hall. The firm was also renowned for its iron bridges. The largest was Southwark Bridge over the Thames, which was completed in 1819. As the business prospered, second generation Walkers moved to large purpose-built residences; for example, Joseph, Samuel's third son, moved to Eastwood House (now demolished) and Joshua, Samuel's second son, moved

Samuel Walker.

A Walker cannon outside Rotherham Town Hall.

Southwark Bridge over the Thames. John Guest, 1879.

to Clifton House (*see* Chapter 6). Both houses were designed by the York architect John Carr. In addition to their Rotherham works, the firm also owned Gospel Oaks Ironworks in Staffordshire and Milton Ironworks at Elsecar. The firm was wound up and sold off in 1823.

Park Gate Iron & Steel Works

The firm was established in 1823 and its first blast furnace was erected in 1839. Its early prosperity was based on the production of rails for the rapidly expanding railway network. In 1856, when the Jarrow shipbuilders Palmer Brothers were asked to investigate the building of an iron-clad ship, they approached the Park Gate company to conduct trials to make armour plate. For a number of years afterwards the company was the sole supplier of armour plate to the Admiralty. The plate for Brunel's steamship, the *Great Eastern* (launched in 1858), was made here. In the twentieth century the works supplied special compressed steel for the car industry and during the Second World War brake drums for RAF bombers became a speciality. The last steel plate was rolled in 1946 and production concentrated on the manufacture of steel bars and tubes. The works were demolished in 1976 and most of the site is now covered by a new road network and a retail park.

In the early 1960s the then owners of the Park Gate Iron & Steel Works, Tube Investments, decided to build new production units, and one of these was erected at Aldwarke, adjacent to the Park Gate works on the flat land between the railway and the River Don. At the time of writing it has just been sold by Tata Steel to Liberty Steel and specialises in the production of cast and rolled specialist steels.

Park Gate Iron & Steel Works.

Manvers and Wath Collieries, Coke Ovens and By-product Plants

Manvers Main Colliery operated from 1870–1988 and the adjacent Wath Main Colliery operated from 1879–1988. The first sod at Manvers Main No. 1 Colliery was turned in 1867 and the Barnsley Seam was reached in 1870 at a depth of more than 280 yards when the first coal was raised to the surface. There were four shafts at Manvers Main. Coke and coal by-products production began in 1878. While all these developments were taking place at Manvers Main, a second colliery was being sunk and expanded just over half a mile to the north-west on Great Moor – between the Midland and South Yorkshire railways. This was Wath Main Colliery where the first coal was raised to the surface in 1879. By the early 1940s the Barnsley seam was exhausted and the exploitation of other seams began. Between 1955 and 1956 a new central coal preparation plant, the biggest in Europe, came into operation. In 1986, Manvers, Wath and Kilnhurst collieries merged to form what was known as the Manvers Complex, but this was closed in 1988.

The impact of coal mining development on the flood plain to the north and east of the village of Wath and on the village itself was immense. It was a landscape that for more than a century was dominated by colliery headgear, smoking chimneys, railway sidings, pit heaps, coal preparation plants, coke ovens, coal washeries, and, for the greater part of the period in question, the constant noise and steam from steam locomotives handling the coal, coke and other by-products. Altogether in 1938 Manvers and Barnburgh Colliery (also owned by Manvers Main Colliery Co.) employed 5,000 men and this was still as high as nearly 2,400 in 1981.

Manvers and Wath collieries, their coke ovens and by-product plants, their pit heaps, railway sidings and marshalling yards have now disappeared. Having lain derelict for more than half a decade until the mid-1990s, the whole area has been reclaimed and landscaped and is now the site of extensive industrial warehousing, light industry,

Manvers Main Colliery, Wath.

The site of Manvers Main Colliery today.

office space and residential development in a lakeside setting. The area also includes the RSPB Old Moor Wetland Centre, a 250-acre nature reserve designed by the Wildlife and Wetlands Trust.

DID YOU KNOW?
Rotherham played a crucial role in the early years of the rapidly expanding railway networks across the world through the manufacture of railway wheels and axles. They were exported to the British colonies around the world and to South America. A leading firm was Sandford, Owen & Watson, which traded under the name Owen's Patent Wheel, Tire & Axle Co. Ltd from 1864. Examples of their 3-foot railway wheels were displayed at the Great Exhibition in Hyde Park in 1851.

Atlas Street and Thurcroft: New Mining Villages
As coal mining expanded eastwards across the exposed coalfield in the nineteenth century, and then onto the concealed coalfield in the twentieth century, a series of settlement explosions took place. Migrants flocked in from every corner of the country and beyond. But it was not only the urban centres that grew and changed at a rapid rate.

Agricultural villages were changed almost overnight into mining villages and completely new mining settlements also sprang up.

In Brinsworth, just to the east of Rotherham Main Colliery, which was sunk in 1876, a completely new colliery settlement called Atlas Street was created. It was named as such after the Sheffield Steelworks of the owners John Brown & Co. Ltd. It was a perfectly straight street village. Apart from the Co-operative stores, every building was residential. Beyond the southern end of the street stood the Atlas Hotel and St George's Church. Altogether 747 men, women and children lived on Atlas Street in 1901. In that year there were 242 employed men and boys living on the street, of whom 212 (87.6 per cent) were colliery workers. Among the other workers there was a night soil man and a stick hawker. Most of these 242 men and boys were migrants. Only forty (16.5 per cent) were born within what is now the modern metropolitan borough of Rotherham. Forty-one (17 per cent) were from the rest of South Yorkshire and another twenty-four (9.9 per cent) were from other parts of Yorkshire. Other important sources of migrant workers were Derbyshire, Leicestershire, Staffordshire and Shropshire. Among surprising birthplaces of residents of Atlas Street were Maidstone in Kent, Dunstable in Hertfordshire and Saxmundham in Suffolk. And as usual there were a few miners from Wales, Scotland and Ireland.

Atlas Street as shown on the 25-inch OS map published in 1928.

Thurcroft lies right on the eastern edge of the exposed coalfield, but did not exist as a village until the twentieth century. Before then it consisted of Thurcroft Hall in its park and a small number of farms; no church, no chapel, no school. As Revd Joseph Hunter put it in his *South Yorkshire* (1828–31, p. 294), 'Thurcroft Hall is a handsome mansion with a view of great extent of open country.' In 1902 Thomas Marrian Jr, owner of the hall and surrounding estate, leased the mineral rights to the Rothervale Colliery Co. Sinking of the colliery began in 1909 and the Barnsley Seam was reached in 1913 at 850 yards deep. By the 1930s more than 2,000 men were employed at the colliery.

In 1901, before the colliery was sunk, the Thurcroft area was part of the parish of Laughton, with a parish population of 631. The area on which the colliery and the colliery village was to be built was farmland belonging to three farms – New Orchard Farm, Sawn Moor Farm and Green Arbour Farm with a population of just twenty. This rural area and the way of life of its inhabitants would be totally transformed in the next decade. The first streets laid out and built by the colliery company in 1914 were composed of short rows of terraced housing. Each house had its own front garden and inside there was a bath connected to a copper to provide a direct supply of hot water. Further residential development by the colliery company took place in the mid-1920s to the east of the pre-First World War village. By 1921, just eight years after the colliery opened, the population of Laughton parish had risen to 2,679, most of it associated with the growth of the new colliery village at Thurcroft.

Peter Street, Thurcroft, one of the pre-First World War rows in the new village.

Maltby and the Development of the 'Model Village'

Not only were new mining villages created, but the impact of coal mining on previously small rural villages was also almost overwhelming. Until 1905 Maltby was a small, sleepy estate village just inside the magnesian limestone belt on the road between Rotherham

Maltby model village as shown on the OS 6-inch map published in 1928.

Housing in Maltby model village.

and Tickhill. Most of the inhabitants were tenants and/or estate workers on the Sandbeck estate of the Earl of Scarbrough, who resided at Sandbeck Hall. The Hall was surrounded by Sandbeck Park, which in 1905 still contained deer. Apart from a few incomers the only strangers that the inhabitants of Maltby would have seen before 1905 would have been tourists in wagonette visiting the nearby ruins of Roche Abbey. But in 1905 everything was about to change. In that year the Earl of Scarbrough signed a sixty-year agreement with the Sheepbridge (Chesterfield) Coal & Iron Co. to mine the coal beneath the Sandbeck estate. In his autobiographical *Brother to the Ox* (1940), the Maltby writer Fred Kitchen described the upheaval caused by the building of a new railway and the sinking of the colliery: the inconvenience for farmers, the blasting and rumbling, the disturbance of wildlife, the building of a new temporary town (Tin Town) for the railway builders, the arrival of navvies and drunken brawls on Saturday night. 'Not since the time of the Danes had our village suffered such an invasion,' he wrote. But some villagers took advantage of the situation. Instead of having a card for tourists at their front door stating that tea was provided, they replaced it with another one simply saying 'Lodgings'. In 1901 the population of Maltby was 700. By 1921 it was 7,657.

The first permanent houses of the so-called model village, which had been designed by Maurice Deacon and built by a local building company headed by Herbert Mollekin, were completed in 1910. The first part of the new village was comprised of two concentric circles on land to the east of the old village and around 1 mile to the south-west of the colliery. The inner circle contained semi-detached villas, with typical half-timbered front gables for senior officials, a new Anglican church (dedicated on Ascension Day, 16 May 1912) and a parsonage. At its centre was a bandstand. In the outer circle short rows of terraced houses (eight houses in a row) were built for mining families. The first street

in the outer circle was called Scarbrough Crescent in honour of the owner of the land, the Earl of Scarbrough. The model village was then extended outwards to fill a roughly triangular area bounded by Morrell Road in the west, Muglet Lane in the east and Victoria Road in the south. By 1912 more than 500 houses had been built in the model village. On Muglet Lane a Miners' Institute was built, and across the lane was a sports ground and pavilion and allotments. A new school, Maltby Crags on Blyth Road on the western edge of the model village, opened in 1912.

Yates & Haywood & Co. Ltd and their Effingham Works

The Effingham Works, once claimed to be the biggest of its kind in the world, was opened in 1855. James Yates (1798–1881) was a great-great-nephew of Samuel Walker, Rotherham's first eminent industrialist, and he worked as a young man at the Walkers' foundry and then in a managerial capacity at their Gospel Oak ironworks in Tipton, Staffordshire. George Haywood had previously worked as a designer and model-maker in two Sheffield foundries. Yates & Haywood & Co., the successor to two earlier firms, came into being in 1846. From the beginning they specialised in the manufacture of fireplaces and kitchen ranges and their products were exhibited at the Great Exhibition in 1851. The firm took

A Yates & Haywood fireplace.

Yates & Haywood factory premises today.

advantage of the market for fireproof heating and cooking products, which expanded enormously as Britain's urban and industrial population exploded in the nineteenth century and new housing was built to accommodate the workers and their families. The firm operated for 150 years. The *Rotherham Advertiser* announced on 4 December 1970 that the firm would close down on Christmas Eve. It was the last of Rotherham's stove grate and fireplace manufacturers, which once numbered more than thirty. Today the Effingham Works still stand and are used by a number of different businesses.

Guest & Chrimes, Iron & Brass Founders

The remains of Guest & Chrimes' iron and brass foundry, built in 1867, still survive on Don Street, Masbrough. The firm's greatest contribution was the supply of products that reduced poor drainage and improved public water supplies and led to great improvements in public health. Richard Chrimes (1815–97), co-founder of the firm, was the brother of Edward Chrimes, who invented the screw-down tap in 1845. After his brother's death in 1847, Richard formed Guest & Chrimes with partner John Guest, also well known as the author of *Historic Notices of Rotherham* (1879). They made a wide range of products,

Above: Ruins of Guest & Chrimes factory.

Left: An old advertisement showing Guest & Chrimes products.

including water and gas pipes, fire hydrants, water and gas meters and manhole covers. After the Second World War a big market developed for valves for oil pipelines and refineries in the UK and the Middle East. As late as 1987 the factory was still producing 1,000 fire hydrants a week. The firm closed in 1999.

DID YOU KNOW?
Steel, Peech & Tozer's (Steelo's) steel-melting shop, which began production in 1917, was built on the site of the Roman fort of Templeborough, where traces of Roman ironworking were discovered during excavations in 1916. The final melt at Templeborough took place on 25 November 1993, and the great melting shop reopened as the Magna Science Adventure Centre in April 2001.

Magna Science Adventure Centre.

4. Notable Residents and Visitors

The Aristocratic and Political Elite

What is now Rotherham Metropolitan Borough was once peppered with the homes of the aristocracy. Wentworth Woodhouse was the home of twelve earls and two marquises over a period of more than 400 years. The earls of Scarbrough and their antecedents, the earls of Castleton, made their home at Sandbeck Park, where the 13th Earl still resides. Kiveton Park was the home of the Duke of Leeds and Holmes Hall and Thundercliffe Grange were the homes of the earls of Effingham.

We have already come across the 1st Earl of Strafford and the 1st and 2nd Marquises of Rockingham of Wentworth Woodhouse in Chapter 2. But the two marquises deserve to have more of their secrets revealed in this chapter. The first is Thomas Watson-Wentworth, the 1st Marquis of Rockingham. It was he who conceived and had built the eastward-facing Palladian mansion at Wentworth Woodhouse, which, at 606 feet, has the longest front of any stately home anywhere in the country. By the time he died he had spent £90,000 on building expenses – many millions in today's money. In 1750, the year of his death, he wrote in a letter to his son: 'If you lay out your money on improving your seat, land, gardens, etc, you beautifye the country and do the work ordered by God himself.' He was also a pioneer grower of pineapples, which he said were very scarce in England. In 1740 he said he had got their cultivation 'to great perfection' and had produced one that weighed 3.5 lbs and was '20 inches in girth the long way round and 16 inches the other'.

His son, the 2nd Marquis of Rockingham, was a leading Whig politician who was prime minister twice. He died in office in 1782 and had advocated the granting of independence to the American colonies. He was buried in York Minster, with the location marked by a statue but there is also a mausoleum in Wentworth Park. Here the marquis is portrayed as a Roman senator. Around the walls are niches containing busts of the members of his 1782 cabinet.

The 3rd Earl of Effingham (1746–91) strongly disapproved of the attitude of the British government towards the American colonists and demonstrated this publicly by renouncing his commission in the army in 1775 and speaking vehemently about it in the House of Lords. He also built a hunting lodge cum rural retreat in 1773, which he ultimately called Boston Castle. This was to commemorate the Boston Tea Party, when more than 300 chests of tea were dumped in the harbour at Boston, Massachusetts, after a fiery debate about the heavy tea taxes being levied by the British government. No tea was allowed to be drunk in Boston Castle! In 1789 he was appointed Governor of Jamaica but his tenure was short-lived: his wife died in October 1791 and he died just a month later. There is a monument to them in the English church in Spanish Town, Jamaica, where they were both buried.

Statue of the 2nd Marquis of Rockingham in the mausoleum in Wentworth Park.

Boston Castle, John Guest 1879.

Another leading local family were the Reresbys, associated with Thrybergh from c. 1328. Sir John Reresby (1634–89), who succeeded his father in 1646, was a close associate of the royal family in exile following the Civil War and was later appointed Governor of York. He is best known as a diarist, whose memoirs were published in 1735. Unlike other diarists mentioned in this chapter, he concentrated most particularly on his own life and times rather than focusing on descriptions of places visited. In 1936 Professor Andrew Browning wrote 'The Memoirs rank with Evelyn and Pepys as authorities for the later Stuart period'. Sir John wrote about the development of his Thrybergh estate in the 1660s and 1670s, rebuilding the house as well as restoring the garden. His father's garden was of a very ambitious design so far north and Sir John added a *jet d'eau* and a grotto. In 1676 he represented the Sheffield cutlers in their opposition to the Hearth Tax, which had caused them great suffering. Today his memorial can be seen in St Leonard's Church.

Thomas (Tom) Paine (1737–1809) is often referred to as one of the Founding Fathers of the United States of America. Two of his pamphlets inspired the American rebels to seek independence from England. He was also closely associated with the French Revolution,

Sir John Reresby's memorial in St Leonard's Church, Thrybergh.

Title page of the first edition of Sir John Reresby's *Memoirs*.

writing the famous *Rights of Man* in 1790 in defence of the Revolution against conservative critics such as Edmund Burke. Much less well known is Paine's talent for designing iron bridges and it was this that brought him to Rotherham in 1788–89. In conjunction with Thomas Walker and his Masbrough ironworks, Paine, along with Walker's foreman William Yates (soon to become a much more important figure in Rotherham), oversaw the manufacture of a 'half rib' of a bridge to be 90 feet long (with an elevation of 5 feet). In February 1789 he stated in a letter to Thomas Jefferson, a key individual in the early history of the USA and the third US president, that a Mr Foljambe wanted a bridge built to replace an 'old ill-constructed' one over the River Don that ran past the front of his house (Aldwarke Hall). Foljambe saw the half rib in the yard at Masbrough and declared, 'In point of elegance and beauty it far exceeded my expectations.' Paine's letter continued, 'My Model and myself had many visitors while I was at the Works (Masbrough). A few

Gillray cartoon of Tom Paine.

days after I got there, Lord Fitzwilliam, heir to the 2nd Marquis of Rockingham, came with Mr. (Edmund) Burke.' So in February 1789 two of the world's most renowned political thinkers (and soon to be the most bitter of political enemies), Paine and Burke, met in an ironworks yard in Masbrough to look at a model of a bridge's half rib. You do wonder if they got on then!

Much more recently, another locally born man has risen almost to the top of the political ladder. This is William Hague (b. 1961), who was born in Rotherham and attended Wath Comprehensive School before going to Oxford. He had a successful undergraduate career, becoming President of the Union and gaining a first-class honours degree. He gained fame when he addressed the Tory Party conference at the tender age of sixteen. After entering Parliament as MP for Richmond, he rose to become leader of the Conservative Party (1997–2001), Foreign Secretary (2010–14) and Leader of the House of Commons (2014–15). He now sits in the House of Lords as Baron Hague of Richmond.

DID YOU KNOW?
John Wesley (1703–91), 'the father of Methodism', and his brother the hymn-writer, Charles, were regular visitors to Barley Hall near Thorpe Hesley. But not everyone extended a warm welcome to the travelling preachers. Opponents of Methodism would beat drums during a sermon or bring in a bucket of blood to throw over the preacher and congregation. In 1743 when Charles Wesley was turning down the lane to Barley Hall, an ambush arose and the party was assaulted with 'stones, eggs and dirt' and he had to be rescued by a local ploughman.

John Wesley.

Literary and Artistic Figures

Ebenezer Elliott (1781–1849) was born in Masbrough, worked in his father's foundry and then went into the same business on his own account. His early verse was about romance, broken hearts and early death, but this subject matter was dropped after the passing of the Corn Laws in 1815 (which were not repealed until 1846). The Corn Laws were designed to restrict the import of grain and resulted in good profits for landowners while driving up the price of bread. To Elliott these laws not only interfered with free trade but increased the possibility of unemployment and famine. He attacked the laws unremittingly through poems, hymns and the press and became a household name. He signed himself Ebenezer Elliott, CLR (Corn Law Rhymer). He is buried in Darfield Churchyard.

Reginald Gatty (1844–1914), the eldest son of Alfred Gatty, vicar of Ecclesfield, was rector of Hooton Roberts from 1888 until his death. Besides his church duties he led a full and active life. He wrote poems and words to songs and carols (including the still popular local carol, 'Christmas Voices'). He also wrote reflective and informative articles for popular magazines like the one edited by his mother (*Aunt Judy's Magazine*) and the *Cornhill Magazine* and *Chambers's Journal*. He was a collector of traditional local furniture and after his death some of this furniture was bought by Earl Fitzwilliam. He was also a well-known archaeologist who wrote up his findings in the archaeological magazines of his day. He amassed a collection of 3,000 flint implements. They are now in Sheffield, Rotherham and Doncaster museums. He was particularly interested in the Mesolithic period and became an expert on microliths, which he called 'pygmy flints'. One of his sons, Nicholas Comyn Gatty, became a composer of orchestral, chamber and piano music and operas. A regular visitor to the rectory was the composer Ralph Vaughan Williams, who came with his wife every summer from 1898 to 1914. Vaughan Williams composed 'Linden Lea' in the vicarage garden in 1901 and it received its first public performance in the village in 1902.

Ebenezer Elliott.

Reginald Gatty.

Edith Jagger (1881–1977), Charles Sargeant Jagger (1885–1944) and David Jagger (1891–1958) were the children of Enoch Jagger, who was manager of Kilnhurst Colliery. Edith Jagger is best known as chief designer for Painted Fabrics Ltd, which was a company developed to provide physical and psychological rehabilitation for injured servicemen during and after the First World War. She later concentrated on her oil paintings of still life, landscapes and flower subjects. Charles Sargeant Jagger was a sculptor, best known for his war memorials. His best-known sculpture is the Royal Artillery Memorial at Hyde Park Corner in London. He also sculpted the memorial to Ernest Shackleton, the explorer, at the headquarters of the Royal Geographical Society in London and his sculptures can be seen in France, India and Australia. His younger brother, David Jagger, was a renowned portrait artist who painted the portraits of politicians, including Winston Churchill in 1939; famous film stars, such as Vivien Leigh in 1941; and the royal family – Queen Mary in 1930 and 1932 and George VI in 1937. His final unfinished portrait was of the Duke of Edinburgh.

Fred Kitchen (1890–1969) was born in Edwinstowe, Nottinghamshire, but his parents moved to South Yorkshire shortly after his birth where his father was a cowman on the Earl of Scarbrough's estate at Sandbeck Park near Maltby. Kitchen worked as a farm labourer, at a colliery coking plant, and on the railways. In his thirties he joined a WEA

David Jagger's statue of Sir Ernest Shackleton outside the Royal Geographical Society building, London.

class and was inspired to write his autobiography *Brother to the Ox*, published in 1940. It was very well reviewed, with H. E. Bates saying that 'Mr Kitchen writes as the grass grows'. It was filmed for Yorkshire Television in 1981. Altogether he wrote sixteen books, and in later life worked as a journalist and radio broadcaster. His diaries (*Journal of a Joskin*) were broadcast as fifteen-minute dramas on BBC Radio 4 in 2013 and 2015.

Roger Dataller (1892–1980) was the pen name of Arthur Archibald Eaglestone. He was born in Parkgate, the son of a former miner who had set up a small mineral water business. As a young man he worked as a colliery timekeeper, then wrote the successful *From a Pitman's Notebook* and won a scholarship under the Miners' Welfare Scheme and went to Oxford. He then came back to South Yorkshire as an adult education worker and went on to become a successful writer. By the time of his death he had written two sequels to his first book, two novels (one of which was made into a film in 1941), two books of criticism and two series of BBC broadcasts. Under his real name he also co-authored a history of Rockingham pottery. His pen name, Dataller, was a worker paid by the day, and as the man himself put it 'and whose pace was generally regarded (sometimes unjustly) as significantly slow'.

Roger Dataller.

Travelling Diarists

From the sixteenth century onwards visits were made to Rotherham by a number of notable diarists whose observations were subsequently published. What they wrote about Rotherham helps to build up a picture of the town's development.

It is quite possible that John Leland (1503–52) was the first person to write about Rotherham in a published book. Leland was a famous antiquary who visited Rotherham in 1539 on one of his journeys to the north and described it in his 'Itineraries'. His descriptive itinerary notes were not published until the eighteenth century, but before that date many other writers – such as William Camden – used his notes as information for their own work. Henry VIII commissioned Leland to make a search of England's antiquaries and all written records where the 'secrets of Antiquities were reposed'. In 1539 he wrote that:

> I entered Rotherham by a fine stone bridge of four arches which has a well-made stone chapel on it. Rotherham is a reasonable large market town, with a large and fine collegiate church. The College was inaugurated by an Archbishop of York called Scot, and also known as Rotherham, on the same site as the present and lavishly built brick college; it has a provost, five priests, a schoolmaster who teaches singing, with six choristers, another who teaches grammar and a third who teaches writing. Although between Cawood and Rotherham there is a good supply of wood, yet the inhabitants burn predominantly coal, which is found in great abundance there, and is sold very cheaply. There are excellent coal pits a mile from Rotherham. The town has good smiths manufacturing all kinds of edged tools.

John Leland's early impressions were built on by Celia Fiennes, who visited Rotherham in 1697. She came from Pontefract and wrote, 'Thence to Rotherham, its most deep clay ground, and now the ways are difficult and narrow. Rotherham is a good market town well-built all of stone, the Church stands high in the middle of the town and looks finely, it's all stone and carv'd very well all the outside'. Not long afterwards an even more distinguished writer, Daniel Defoe, came to Rotherham and described it in *A Tour through the whole island of Great Britain*, which was published in 1724–27. He made a reference to the Roman remains at Templeborough, writing: 'The remains of the Roman Fortifications or encampment between Sheffield and Rotherham are there still and very plain'. In the town itself he saw 'nothing of note, except a fine stone bridge over the Don, which is here increased by the River Rother, from whence the Town, I suppose, took its name'. Arthur Young wrote many works that focused on farming at the end of the eighteenth century. His work includes information on soil types, land rents and farming practices and he was greatly impressed by what he saw of agriculture on the Wentworth estate. He stayed locally at the Crown on the High Street in Rotherham and found it 'very disagreeable and dirty, but very cheap'. He also noted that the town 'is famous for its ironworks of which it contains a large one belonging to Mr Walker and one or two smaller. The forge men work by weight and earn from 8 to 20 shillings a week, while the foundry men are paid 7 to 10 shillings a week'. He mentions that a few women were employed in the works, but no boys younger than fourteen. He also mentions a pottery in the town that employed around twenty-two men and forty boys.

Richard Warner (1763–1853) was a clergyman and antiquary who in the years around 1800 undertook extensive walking journeys around England, Scotland and Wales and wrote a number of topographical books describing them. In June 1802 Warner wrote in detail about his visit to Rotherham and its surrounding area and it makes fascinating, and at times surprising, reading. He approached the town via Hathersage and Sheffield. He gives the population of Sheffield at that time as over 45,000 and states that it 'is not represented in parliament'. He described the area between Sheffield and Roherham as 'animated industry; iron-works and coal-pits on each side of the road, and thickly-peopled villages'. The scene continued to Rotherham 'which has a great market for fat cattle and sheep, held there every fortnight, from which the populous country about Manchester and its neighbourhood derive a considerable part of their supplies'. He noted that Rotherham had a population of 3,070 and neighbouring Masbrough had 3,266 residents. He included a detailed description of the processes used by the Walkers to produce cannon and cannonballs. He said that farming labourers in Rotherham earned around 2s a day. He continued,

> The poor in general live comfortably, their situation being much ameliorated by the cheapness of fuel. This gives a surprising cheerfulness to the appearances of their cottages in a winter's evening, warmed and lighted by the blaze of an excellent fire, contributing at the same time to their health as well as enjoyment, a circumstance to which may be probably attributed the remarkable healthiness of the town and neighbourhood, and the almost total absence of epidemic disorders.

As he left Rotherham towards Wentworth, from a hill to the north of the town (perhaps near Barbot Hall), he looked back at the view and 'beheld a picture of such richness and variety as, perhaps, no other part of England can afford ... an extremely grand country disclosed itself, undulating into broad hills and wide valleys, whose boundless fertility is assisted by an admirable system of agriculture'.

Entertainers and Sportsmen

Albert Arthur 'Sandy' Powell was born on 30 January 1900 but he was known as Sandy throughout his career in entertainment because of his bright red hair. His mother, Lily, had been born in a Yorkshire workhouse and toured the smaller halls of northern England with a marionette act before marrying in 1898. Sandy's father left his family four years after Sandy's birth in Rotherham. Sandy went to White's school in Masbrough but poverty forced Lily back on the road. She took stage jobs when she could but otherwise worked as a singing waiter in pubs. It was Lily who taught Sandy to read and write as very little of his time was spent in school. At the age of nine (and with a fake birth certificate) Sandy went on stage alone for the first time as a boy soprano, but his voice broke in 1912 and so began his long – and eventually very successful – career as a comedian. Early on, though, there were certainly times when he had to take casual jobs in factories to get by. He was spotted by a London agent while performing with his mother in Dewsbury and he got a two week trial at the Shepherd's Bush Empire in London. From then he appeared on stage with greats such as George Formby, Marie Lloyd and Vesta Tilley. In 1928 he did a summer show in Blackpool and made his first broadcast on radio. He made eighty-five records between 1929 and 1942, including several with Gracie Fields. His radio work began in earnest in the 1930s and his catchphrase 'Can you hear me mother?' became recognisable to most people in the country. He worked continually on radio, television and pantomime in the 1940s and 1950s. He also starred in eight films between 1932 and 1948. When a new pub opened above the indoor market in Rotherham in 1970 Bass Charrington wanted to name it 'The Sandy Powell', but Sandy modestly suggested 'The Comedian' instead. He died in 1982 and was still performing occasionally up to that time.

In the 1960s a new style of entertainment became established in Britain's industrial heartlands, with shows involving well-known stars and variety acts performing for largely working-class audiences. A new club, Greasbrough Social Club, and perhaps the first of this new style, was established on Fenton Road in Greasbrough in 1961 by a local man named Les Booth. A proper performing hall was built with a crowd capacity of around 800 people seated and alongside a ballroom. The bar was kept outside the performing hall and generally audiences treated the performers with the utmost respect. Admission charges for most of the evenings were 5s. In 1965 the club had a membership of over 2,000 and drew national attention in the press when the committee attempted to attract Sammy Davis Jr from sunny Las Vegas to appear in Greasbrough with an offer of £2,000 for a week – he was not tempted. The stars who did perform there were some of the best-known entertainers of the time, such as Dicky Valentine, Jayne Mansfield, the Seekers, Johnny Ray, Matt Monro, the Shadows, Adam Faith, Lonnie Donegan, Val Doonican and, perhaps more bizarrely, Mandy Rice-Davies (linked with the Profumo

Arthur Wharton in the 1880s.

Scandal). It closed in 1969 when financial concerns became too pressing but the building remains, converted mainly into a Co-op supermarket.

Arthur Wharton (1865–1930) is believed to be the first black professional footballer. He was born in the Gold Coast (Ghana), the son of a West Indian Methodist minister. His father died in 1873 and the following year Arthur was sent to school in London. As an adult he showed real sporting promise, excelling in athletics, football and cricket. In 1886 he entered the AAA 100 yards Sprint Championship at Stamford Bridge and won it in a world fastest time of ten seconds dead. In 1887 he played in goal for both Preston North End and Middlesbrough, as well as having his first game with Sheffield United. He also set a cycling record in a tricycle race from Blackburn to Preston. The Football League began in 1888 and Arthur was involved, moving from Darlington to Sheffield. He became a professional runner training in Sheffield with other black runners. He also trained in Wickersley. In 1889 he played professional cricket for Greasbrough. In the following year Arthur married Emma Lister from Rotherham and played in goal for Rotherham Town. He was dubbed 'the best goalkeeper in Northern England'. In 1891, having retired from professional running, he took over the Albert Tavern in Masbrough to try and make ends meet. He was also playing cricket for Rawmarsh. In 1892, in recognition of his service to the club, Rotherham Town played Doncaster Rovers in a benefit match for Arthur at the Clifton Grove Ground. A crowd of 2,500 watched Rotherham win 3-0 with Arthur in goal. In 1915 Arthur moved to Edlington, dying there in 1930.

> **DID YOU KNOW?**
> Both Alan Simpson and Peter Elliott grew up in the Rotherham area and both were world-class middle-distance track runners, despite holding down jobs in local steelworks for parts of their careers. Both competed in Olympic 1,500-metre races, with Simpson coming fourth in the 1964 final in Tokyo behind the winner, Kiwi Peter Snell, and Elliott finishing second in the 1988 final in Seoul behind Kenyan, Peter Rono. Both still live in the local area.

Thomas William Burgess (1872–1950) was born at Lyndhurst Place in Rotherham, the son of Alfred, a blacksmith. He learned to swim when very young. In 1881 he was living at No. 26 Bethel Road, Rotherham. Soon after he moved to Westminster, London, with his family and swam along the Thames to Battersea when just a boy. He emigrated to Paris when an adult (and lived there for the rest of his life) working in a motor tyre business. He made numerous attempts to swim the Channel and finally succeeded on his sixteenth attempt in September 1911, the second man to be successful following Matthew Webb in 1875. His epic swim began in St Margaret's Bay near Dover and was completed at Cap Gris Nez in France over twenty-two hours later. He received a telegram from George V at Balmoral as well as one from Captain Webb's son. Thomas also helped Gertrude Erdele to become the first woman to swim the Channel in 1926. Many older people in Rotherham know of Thomas because there was a bronze bust of him at the old Sheffield Road Baths until they were demolished. The bust was moved to Clifton Park Museum.

John 'Jack' Lambert (1902–40) was born in Greasbrough in 1902, the son of John and Annie Lambert. He was brought up in a large family that lived in Church Street, Greasbrough, in 1911. His father was a coal miner and one of his older brothers was a pony driver in the pit. He played football for Greasbrough before moving on to play for Methley Perseverance, and he first played professionally for Rotherham County before moving to Leeds United in 1922. He did not really make a breakthrough until he joined Doncaster Rovers in 1925, where he started to score regularly. Herbert Chapman, the famous manager (who was also born in Rotherham at Kiveton Park), signed him for Arsenal in 1926 but he only became really successful towards the end of the 1929–30 season, when he scored eighteen goals in just twenty matches. He played in the 1930 FA Cup Final against Huddersfield Town, scoring one of the goals at Wembley in a 2-0 win. He led the line alongside forwards that included David Jack, Alex James and Cliff Bastin. He received a tremendous welcome on his return to Greasbrough after the final to receive a presentation from the community. The following year he had his most prolific season scoring thirty-eight goals in thirty-four appearances, a club record and more than a goal a game – an outstanding achievement. In that season he scored seven hat-tricks. In all he won two Cup Final medals and two League Championship medals before being sold to Fulham in 1933. He retired from playing in 1935. He was killed tragically in a road accident in 1940 while driving a van during the process of moving house.

Frederick (Fred) Sewards Trueman (1930–2006) was born at Scotch Springs, a terrace row in the countryside around half a mile from the small village of Stainton near Maltby.

Jack Lambert on his wedding day with his best man, Alex James, the famous footballer.

He came from a farming family although his father Alan later worked at Maltby Main. Alan was a keen cricketer, the captain of Stainton's team, and used to take Fred to matches when he was very young. Later the family moved to Tennyson Road in Maltby and Fred went to Maltby Secondary School, where he was soon playing with much older pupils in the school team. In 1946 he played regularly for the Roche Abbey team before joining Sheffield United, who played at Bramall Lane. Early in the 1948 season he played for Yorkshire Under 18s team alongside Brian Close and Ray Illingworth. In 1949 he made his debut for the first team. In the winter Fred worked at Maltby Main Colliery in the tally office (but never as a miner). He did his national service in the RAF at Hemswell in Lincolnshire, starting after the 1951 season, and was demobbed in late 1953 but still managed to play some cricket, including making his England debut in 1952. In thirteen years he played only sixty-seven times for England but took more Test wickets than anyone had ever done at that time – and at an impressive average of 21.57. His last first-class match was played in 1969 and for many years he was Yorkshire's main strike bowler, taking 100 wickets in a season on twelve occasions. He was made on OBE in 1989 and died in 2006.

Gordon Banks and David Seaman grew up in the Rotherham area, Banks in Tinsley and Catcliffe and Seaman in Kimberworth. Both became world-famous goalkeepers, Banks earning seventy-three international caps for England and Seaman seventy-five. Banks played much of his club football for Leicester City and Seaman for Arsenal. Banks won a World Cup Winners medal in 1966 –something Seaman did not achieve – and produced one of football's greatest saves from Pele's header in Mexico in the World Cup in 1970.

DID YOU KNOW?
Sir Donald Bailey, the war-winning engineer and inventor of the Bailey Bridge, was born in Albany Street, Rotherham, in 1901 and attended Rotherham Grammar School. His bridges were said to have doubled the effectiveness of the Allied armed forces during the Second World War. Nearly 2,500 Bailey Bridges were erected during the Italian campaign between 1943 and 1945, and another 1,500 across Western Europe after the D-Day landings in 1944, including a 2,000-foot bridge across the Rhine.

5. On This Day...

The Battle on Rotherham Bridge, 2 May 1643

On this day in the first year of the English Civil War, William Cavendish, the Earl of Newcastle, led his army to enforce support for Charles I's cause by clearing the Parliamentarians from the south of Yorkshire, and, more specifically, attempted to take control of Rotherham. The Earl was the king's commander in the northern counties and Rotherham was one of many local towns where the inhabitants generally supported Parliament rather than the king. He led an army of possibly 8,000 men and attacked Rotherham as a prelude to an assault on Sheffield Castle. They passed quickly through the main street in Masbrough, but on approaching the bridge they found it barricaded by the townspeople. Among these townspeople were reported to be thirty boys from Rotherham Grammar School. The defenders used a single piece of artillery called a 'drake' (which could fire a 5-pound ball) to good effect. They killed Captain Francis Errington of Denton and caused other casualties among the Royalist force.

They managed to hold up Newcastle's advance on Sheffield Castle for two days, but eventually they ran short of ammunition and several houses were set alight by grenades fired by the attackers. An honourable surrender was agreed between the two sides but the terms were soon forgotten or ignored and Newcastle's army plundered the town.

Rotherham Bridge.

A fine of 1,000 marks (£666 – an enormous sum) was imposed upon the town and the same amount on each of its four leading citizens – William Spencer, Henry and George Westby and John Shaw, the vicar. John Shaw, a strong Puritan, hid in the attic of an empty house for three days and escaped capture before fleeing to Manchester. He is buried in the parish church. The defenders of Sheffield Castle showed much less resolve than those in Rotherham and fled the castle on hearing the news from Rotherham.

The Masbrough Boat Disaster, 5 July 1841

On this day a seagoing boat known as a Yorkshire keel was launched from Chambers' boatyard, Providence Dock, Masbrough, into the River Don. The *John and Mary* was launched sideways, as was usual because of the narrow river channel. It was a gala day for the town and every vessel in the area had a flag. On such occasions boys were allowed to stand on the deck as the boat slid into the water. It is believed that the rush of people on-board towards the river side caused the boat to overbalance and as John Hague of Toronto, Canada, remembered fully fifty years later, 'casting some 50 boys into the water, over whom the boat fell like a lid on a pot. There they were under its huge frame and smothered or drowned'. John himself should have been on the boat, but his nurse Ann Newsum had second thoughts and at the last moment flung him into the arms of a boatman and sprang to the ground herself. On the banks the screaming, horrified and frantic crowd watched as desperate efforts were made to save those trapped under the boat. Fathers and boatmen slashed furiously at the bottom of the boat with axes to try to rescue the children, but the death toll still reached fifty, of which just four were adults. All the bodies were collected by 7 p.m. and Rotherham and Masbrough 'never had a sadder day than when, through the hushed streets, these poor boys were borne on litters to their homes'. John lost his best friend in the accident, the son of James Yates, the famous industrialist. William Creswick also remembered the event years later and controversially held the opinion that

Illustration showing the boat disaster from the *Penny Sunday Times*.

Plaque to the boat disaster victims at Rotherham Minster.

the death toll would have been much lower if the boat's keel had been left intact with air trapped beneath it. He recalled men diving underneath the boat and bringing children out 'in strings'. He also recalled pulling 'six out by the hair of their heads'.

DID YOU KNOW?
On 7 November 1730 Joseph Foljambe of Eastwood patented his invention, the Rotherham Plough. Foljambe had the idea of making the fittings and coulter of iron rather than wood, and the wooden mouldboard and share that were still used were covered with iron plate. This made the plough more efficient and lighter and could be drawn by just one pair of horses or oxen. One man could control the draught animals and the plough. This became the standard plough in Britain for close to 200 years, when tractors replaced horses. It was perhaps the first plough to be factory produced on a large scale.

Foundation Stone Ceremony at St Bede's Catholic Church, Masbrough, 29 July 1841
On this day the foundation stone of a new Catholic church was laid by Revd James Staples. The church was to be erected on a site covering 1,000 feet, presented for the purpose by Benjamin Badger of Rotherham. A special train ran from Sheffield to Masbrough station to convey the 350 Sheffield Catholics who attended the ceremony. A procession was

St Bede's Church and churchyard, Masbrough.

formed from the station with the Hibernian Society, the Catholic Temperance Society and the Holy Catholic Guild and headed by their banners and a band of music. After the ceremony the congregation had refreshments in the Crown Inn before returning to Sheffield using their special train tickets.

The Rotherham Election Riot, 21 July 1865

On this day an election for the southern division of the West Riding of Yorkshire – involving Mr Stanhope and Mr Denison for the Liberals and Lord Milton and Mr Beaumont for the Conservatives – resulted in a riot. Considerable damage was done to several buildings in the town and particularly the Crown Inn at the top of the High Street, the Three Cranes, the Black Horse, the shop of Mr Evans, hairdresser and hatter, and Mr Taffinder's jeweller's shop also on the High Street. A newspaper report stated at the time that two of the buildings were almost demolished as a result of attacks, certainly the attack on Evan's shop left 'scarcely a trace of the framework of the window' and he subsequently received nearly £230 in compensation. Both police and military were assaulted in the course of the day. The crowd got stones from a new road near to the station and threw them in hundreds. Mr Gillett, the police superintendent, was severely cut on the head and he and his men were besieged in the Crown Inn. The crowd broke into a lower room and so he sent to the Sheffield barracks for help from the 15th Hussars. The Hussars rode into town with drawn swords but the crowd stood firm, so Mr G. W. Chambers JP read the Riot Act. Yet still the crowd persisted in yelling and stone-throwing, so the soldiers charged them, using the flat of their sabres to lay about them right and left. Thomas David of Parkgate attempted to gain the shelter of the Black Horse doorway, but it was closed against him, and an officer of the Hussars struck him twice through his left arm with his sword. The riot continued until well past 6 p.m. and in all forty of the crowd were apprehended and removed to the cells. Twenty-three of those arrested were charged and subsequently tried in Leeds, where all bar one were found guilty. Two men named

The Crown Inn in 1865 showing damage and the militia.

Lockwood and Chester received the longest sentences of imprisonment – nine months in both cases.

The Christening of Peter, Viscount Milton, at Wentworth Woodhouse, 12 February 1911

On this day a christening – though more like a coronation than a christening – took place at Wentworth Woodhouse. This was because the 7th Earl and Countess Fitzwilliam had had four daughters and it was feared that the earldom would go to another branch of the family. The relative who would inherit if there was no son was an uncle who was seventy years old. Fortunately they had a son, Peter, born in December 1910.

His christening ceremony took place in the private chapel in the mansion at 1 p.m. on 12 February. The *Rotherham Advertiser* reported that the scarf presented to the earl's ancestor at the Battle of Hastings for his 'valour and service' would be wrapped around the baby Peter. There were 7,000 invitations that were sent out to official guests, and, in addition, it was reported that between 50,000 and 100,000 of the general public would also attend. One hundred men from London were sent to erect marquees for thousands of the official guests and 300 waiters came to Wentworth from London by special train. Local tenants, the employees of the hunts that the Earl hunted with, the parishioners of Wentworth and local miners all presented engraved bowls.

In the afternoon and evening there was a full round of festivities, including bands, roundabouts, daylight fireworks and the roasting of an ox to provide beef sandwiches for the public. The event ended with a magnificent fireworks display. It was reputed to be the biggest private firework display for five years. It included portraits of the Earl and

Viscount Milton being shown off by his nurse.

Countess, Niagara Falls and a British battleship attacking and sinking the 'dreadnought' of a continental power.

Everything was caught on camera and made into picture postcards: the presentation of the baby Peter to the public by his nurse, the presentation of engraved bowls to the Earl and Countess, the roasting of the ox and the fireworks display.

Peter became 8th Earl in 1943, but was killed in aircraft accident in 1948.

Queen Mary Rides the Rails at Silverwood, 9 July 1912

On this day Queen Mary and George V visited Silverwood Colliery as part of a three-day visit to the West Riding to enable the king to get 'a close acquaintance with the working conditions in the collieries of South Yorkshire'. In the morning the royal party had been seen by a large crowd at Clifton Park, who greeted the royal car with much cheering. The royal party was then driven to Silverwood Colliery at Dalton, where two lines of ambulance men were drawn up inside the gates, including Privates Ball, Brindson, Roberts, Jennings, Dibbo, Jones and Selby. The king went to the West Pit winding engine house, passing on the way two pit ponies that had been down the pit for five years. The queen saw all that the king saw, apart from the belt house and the washery. She did most of the tour on a railway platelayer's trolley (lent by the Midland Railway) run along the colliery rails and pushed by half a dozen of the colliers. Lady Aberconway and Lady Eva Dugdale were on the trolley with the queen, whose smiles suggested that they rather enjoyed the fun. At the end of the tour the king expressed his satisfaction at the fact that material that used to be wasted was now being used to advantage in the way of by-products. Later that day the royal party visited Rawmarsh, Hickleton and Wath en route to Elsecar Colliery. It was on this same day that the news broke of a terrible pit disaster at Cadeby Colliery nearby, where ninety-one men were killed.

Miners awaiting the arrival of George V and Queen Mary at Silverwood Colliery in 1912.

Queen Mary with her very special transport at the colliery.

Belgian War Casualties Arrive in Rotherham, 30 October 1914
On this day one of the first contingents of wounded Belgian soldiers arrived in Rotherham. They were followed in the next few months by other wounded servicemen from Belgium, as well as hundreds of Belgian refugees. The group, made up of twenty wounded soldiers,

Some of the evacuated Belgian children at Rosehill House, Rawmarsh, in 1915.

was accommodated in the West Ward of Rotherham Hospital. They had arrived at hospital in Sheffield just two days previously. They were taken from hospital in Sheffield to the Midland station by tramcar and then a special carriage was attached to the 11.23 train to get to Masbrough just ten minutes later. They were greeted there by the Mayor of Rotherham, the Vicar of Rotherham, Chief Constable Mr E. Weatherhogg, Mr W. B. Willis (honorary secretary of the Belgian Relief Fund), two surgeons from the hospital and Mr E. de Roeck (an interpreter). Mr de Roeck was of Belgian extraction and was a well-known seed and corn merchant of Frederick Street. Although only a short notice had been received, there was a considerable crowd and the visitors received a hearty welcome as they found places in the Corporation 'busetto', ambulances and taxis. All the men were in uniforms that showed traces of the battlefield. They had sustained their wounds while fighting near Dixmude and Mons. At the hospital everything went quietly and smoothly and Miss Turner, the matron, and her nursing staff, very quickly made all her patients comfortable. Later in the day Father Vos from St Bede's joined Mr de Roeck in the task of interpreting.

Refugee groups that followed were accommodated initially in Eastwood House, Clifton House, Rotherham Golf Club House in Thrybergh and Rosehill Hall in Rawmarsh. These groups were mainly made up of women and children. Locally a great deal of fundraising was going on to support the Belgian refugees, and Miss Adelaide Cooper of Greasbrough had already made 10s 6d through the sale of badges.

The Rotherham Floods, 22 May 1932

On this day a deluge that particularly affected Canklow and Parkgate caused great disruption to Rotherham as the electricity station was put out of action in part and the supply of gas from the coke ovens was completely cut off. As reported in the *Rotherham Express*, 'The floods which caused so much damage in the town nearly succeeded in putting the town in darkness – but not quite'.

One of the earliest incidents of the flood was the removal of a man, his wife and seven children from a lodge on the sports ground near to Stone Row in Parkgate. Not long afterwards the residents of Stone Row itself were alarmed to see the water rapidly

Works officials inspecting the flooded Parkgate Chemical Works in May 1932.

flooding across the fields and the road and up to their doorsteps. Water flooded from a swollen stream to the back of the houses and in some instances into downstairs rooms. The bursting of a wall caused by the overflow of the Greasbrough Dam sent hundreds of tons of water swirling madly towards the South Yorkshire Chemical Works at Mangham, and the trackless service between Rotherham and Rawmarsh had to be suspended. It was also impossible to travel over the Aldwarke Wash. As early as 7.15 a.m. the ovens at the chemical works were closed down and a fire engine was borrowed from Wentworth to pump out the boiler sump. The water was reported to have reached 27 feet deep in the works. Earl Fitzwilliam, owner of the works, was present there for many hours on the Sunday and assisted in giving directions. The railway line near Parkgate was also lying several feet under water and the signalmen on duty had to be rescued. On the following morning the bridge across the river at Canklow, which carried crude gas to the gasworks, was washed away.

Manvers Rail Crash, 18 May 1948

On this day, around 3.50 p.m., a fatal rail accident involving the 11.45 a.m. St Pancras to Bradford Express occurred near Wath Road junction, close to Manvers Main Colliery. One of the two engines toppled down an embankment followed by five coaches, the leading two of which were telescoped. The first engine was partly overturned, the second remained attached to the coaches but was completely overturned. The railway here was straight but the crash was perhaps due to distortion of the rails caused by the sun's heat. Poor maintenance following the war may also have been partly responsible. Eight people died as a result of the accident, including the driver of the train, Bertie Wilshire, and fify-seven were injured. Help for the stricken crew and the passengers came quickly as workers from the nearby Manvers Main pit rushed to the scene with cutting gear and props to stabilise the crash scene. The death toll could have been much higher, however; the train had just 194 passengers because a relief train had carried the bulk of them, which had left St Pancras just fifteen minutes earlier.

Aerial view of the Manvers train crash after the 1948 derailment.

The monument at Manvers erected in remembrance of the 1948 rail disaster.

DID YOU KNOW?
Tom Jones performed at Rawmarsh Baths on 20 March 1965. The pool was covered up by a wooden floor to turn it into a dance hall. When Tom made his appearance the crowd rushed forward and some screaming girls tried to climb on to the stage. The baths' changing rooms were used as dressing rooms. Having been booked some months before 'It's Not Unusual' had charted, Tom appeared at a reduced price. Other stars who performed at the venue around that time included the Hollies, the Fortunes and Freddie and the Dreamers.

6. Rotherham's Countryside

The Metropolitan Borough of Rotherham is still 60 per cent countryside. It contains not only thousands of acres of farmland, but also former medieval deer parks, eighteenth-century landscaped parks, Victorian public parks, twentieth-century country parks, ancient former coppice woods and fragments of commons. And all these countryside sites have fascinating histories.

Deer Parks

Parks are as old as civilisation itself. They originated in ancient Assyria, Persia, India, Egypt, Greece and Rome. More than 3,000 years ago the king of Assyria boasted of parks planted with exotic trees, stocked with oxen, stags and elephants, embellished with fish ponds and beautified with complex water systems and with temples and shrines on artificially created small hills.

Deer parks were the first parks in Britain. Although they certainly existed in England in Saxon times they were few and far between, and the tradition only flourished after the Norman Conquest in 1066. Traces of medieval deer parks can still be found dotted across Rotherham Metropolitan Borough. Indeed in one case, at Wentworth Woodhouse, a herd of deer still grazes in what has been a deer park for almost 700 years. In another now empty deer park, Sandbeck Park, there was a herd of deer until around 1905.

Medieval deer parks were symbols of status and wealth. In South Yorkshire they were created by the Crown, the nobility, and they were also attached to monasteries. As all deer were deemed to belong to the Crown, from the beginning of the thirteenth century landowners were supposed to obtain a licence from the king to create a park. The last

Deer in Wentworth Park.

John Speed's map of 1610 showing deer parks around Rotheram and Sheffield.

known local deer park licence was granted to the 2nd Viscount Castleton in 1637 by Charles I to create a deer park at Sandbeck.

The creation of a park – emparkment – involved enclosing an area of land with a fence to keep the deer and other game inside and predators (in the early days, wolves) and poachers outside. The fence – the park pale – consisted either of cleft oak vertical pales with horizontal railings often set on a bank, or a stone wall. Parks could vary in size from under 100 acres to several thousand.

Deer parks were not created primarily for hunting although hunting did take place in the larger parks. The deer were carefully farmed. Besides its status symbol role the main functions of a medieval park were to provide for its owner a reliable source of food for the table and supplies of wood and timber. Besides deer, hares, rabbits (not native but introduced by the Normans and kept in burrows in artificially made mounds) and game birds were kept in medieval parks. Herds of cattle, flocks of sheep and pigs were also grazed there. Another important feature of Rotherham's medieval deer parks were fish ponds to provide an alternative to meat in Lent and on fast days. The remains of fish ponds can still be seen on the edge of Kimberworth Park.

Deer parks usually consisted of woodland and areas largely cleared of trees. The park livestock could graze in the open areas and find cover in the wooded areas. The cleared areas, called launds or plains, consisted of grassland or heath with scattered trees. The Norman-French word *laund* is, of course, a predecessor of the modern word 'lawn'.

Many of the trees in the launds were ancient or veteran trees. Some of these trees might reach a great age and size. The veteran or ancient trees standing in the launds had a

The outline of Aston Park in the modern landscape.

multiplicity of uses for centuries. When felled they provided timber for building projects and charcoal was made from their branches. Standing, live, the open-grown enormously branched oak trees produced, unlike most woodland-grown oaks, burgeoning crops of acorns. These not only provided the food for fattening pigs during the pannage season, but also for keeping the deer population in good heart in preparation for the long winter. Most park woods were coppiced and were surrounded by a bank or wall to keep out the grazing animals during the early years of regrowth. Later in the coppice cycle the deer would have been allowed into the coppice woods.

Between the late fifteenth and eighteenth centuries many medieval deer parks either changed their function and hence their appearance, or, more commonly, disappeared altogether. Well-wooded parks often simply became large coppice woods, as at Rainbrough Park and Tinsley Park (now in Sheffield but formerly part of Rotherham parish). Other medieval parks simply reverted wholly or largely to farmland as at Aston, and, in two cases, at Kimberworth and Thrybergh, into golf courses.

DID YOU KNOW?
The last known medieval royal licence to create a deer park in South Yorkshire was given in 1491–92 when Brian Sandford was granted permission to create a park at Thorpe Salvin. This grant is also notable for the fact that it was accompanied by a gift of twelve does (female fallow deer) from the king's park at Conisbrough 'towards the storing of his parc at Thorp'.

Landscaped Parks
While hundreds of medieval deer parks throughout the country were disappearing, many others took on a new lease of life. The primary function of a park changed from being a game preserve and a valuable source of wood and timber to being the adornment of a country house. For example the former medieval park at Wentworth Woodhouse was enlarged and

The mausoleum in Wentworth Park.

The Doric Lodge.

beautified during the eighteenth century at the same time that the Palladian mansion was being erected. The 1st Marquis of Rockingham recorded the making of a 'serpentine river', the building of obelisks in the park and Scholes Coppice was 'cut into walks for beauty' and made part of the park. It is not clear who were the designers of the landscaped park, only that in 1790 the landscape architect Humphrey Repton was at Wentworth planting trees and altering the lakes. One of the characteristic features of eighteenth-century landscaped parks, as already noted, is the ornamental buildings that decorate them. At Wentworth Woodhouse there is an Ionic temple on the terrace beside the mansion that contains a statue of Hercules slaying a lion, a mausoleum (a memorial to the 2nd Marquis of Rockingham, who was twice prime minister), and surrounding the park there are still five gatehouses, including the Doric Lodge on Hague Lane, in the style of a Greek temple.

Sandbeck Park, the home of the earls of Scarbrough, was transformed between 1774 and 1780 by the most famous landscape gardener of his day, Lancelot 'Capability' Brown.

The former deer park had already been landscaped by the 1720s with walks, plantations, orchards and a pond. Brown's work included the making of new lakes, woodland planting, the creation of carriageways and avenues and the building of a ha-ha. The ruins of Roche Abbey were included in the design, which involved covering and landscaping some of the ruins with 'a poet's feeling and a painter's eye'.

Clifton House and its Estate

The area now occupied by Clifton Park and Museum was once part of one of Rotherham's open fields, known in 1764 as Gallow Tree Field. The field took its name from Gallow Tree or Gibbet, which it bordered, the latter being placed in a strategic location to deter wrongdoers. It was this site, together with some adjoining land, that was purchased by the industrialist Joshua Walker in the 1780s for the building of his new home and pleasure grounds. It is recorded in a minute book of 1783 that 'Mr Joshua Walker nearly compleated his new house, stables, etc, at Clifton'. This is thought to be the earliest record of the name Clifton – a more pleasant-sounding name than Gallow Tree! Joshua and his wife Susannah have their initials over the back door of Clifton House. It is thought that John Carr, the York architect, designed Clifton House. John Platt was also employed for some internal features. His diary states, '15 Jun 1784 Begun laying Staircase and hall floors Derbyshire marble at Clifton Joshua Walker, Esq'.

When Joshua Walker died in 1815 the estate passed to his elder son, Henry Frederick Walker and when he died in 1860 the entire estate was put up for sale. By this time Rotherham had expanded and the Clifton estate was no longer isolated. When the reserve price was not reached the estate was divided up into nine smaller lots. The largest part including the house, outbuildings, gardens, fishpond and lodge was sold to William Owen, another local industrialist, in 1864. William Owen died in 1883 and his wife, Catherine, the following year. This time the estate was split into seventeen lots, with almost half being offered for building. However, much of the park remained unsold until Rotherham Corporation bought the house and 54 acres of parkland for £25,000 in 1891 'for the use of the townspeople in perpetuity', thus providing the growing local population with much needed breathing space. Clifton Park was opened on 25 June 1891 – and what an occasion!

Clifton House, built for Joshua Walker in the 1780s.

Clifton Park becomes a Public Park

The park was officially opened by the Prince and Princess of Wales (later Edward VII and Queen Alexandra) accompanied by the Princesses Maud and Victoria. The royal party stayed the previous night at Wentworth Woodhouse with the Earl and Countess Fitzwilliam, who were also special guests at the ceremony. As the party left Wentworth Woodhouse 'the barometer was in doubtful mood', but fortunately the sun shone later in the day. On reaching the Corporation boundary the party was 'met by a guard of the Yorkshire Dragoons, followed by liveried out-riders and mounted police'. It had been suggested that Rotherham was much too radical a town to give the royal party 'a right royal reception', but they did, with the royal party being 'greeted with the most cordial manner possible'. Messrs Pain and Sons provided the decorations that lined the route of the royal party.

Also present for the opening ceremony were Rotherham's mayor and his wife (Alderman and Mrs Neill), Councillor W. B. Hirst (Chairman of the Parks Committee) and the Town Clerk, Mr H. H. Hickmott. This was the first occasion at which the mayor wore

Paddling pool in Clifton Park.

The Memorial Gardens, Clifton Park.

his newly acquired robes of office, cocked hat and mayoral chain (made by local jeweller John Mason), the purchase of which had 'met with opposition against extravagance and vulgar display'. The mayor obviously made a great impression as 'driving ahead of the royal carriage he was loudly cheered' and on stepping from his carriage ten thousand children, on specially erected stands, obviously thought he was the Prince of Wales and began to sing their well-rehearsed song, 'God Bless the Prince of Wales' to 'considerable merriment'. The royals and officials then went to Clifton House for lunch.

The *Rotherham Advertiser* described the new park as 'beautifully wooded with trees of a rare type and others of majestic appearance'. The article went on to explain how Mr Albiston, the curator of Boston Park, was to create a number of flower beds 'in elegant designs' on the lawns to the east of Clifton House, which became a museum in 1893. A grotto is also described 'intended to represent a miniature cave' in which 'stalactites hang from the roof' and where the interior is 'studded with coral, fossils, shells, petrifications and various other interesting geological specimens, while the exterior is adorned with other fossils'.

The main entrance to Clifton Park at the corner of Clifton Lane and Doncaster Road was improved in around 1900 with the installation of massive pillars and cast-iron gates. The gates were removed in the Second World War but have since been replaced. The original cast-iron bandstand was removed to Ferham Park in 1919, and a First World War tank then occupied the site until 1927. A new bandstand was erected in 1928 to be replaced by the current one, which was opened by Elizabeth I in 1991 as part of the park's centenary celebrations.

Boston Castle and Boston Park

The Gothic folly Boston Castle began to be built on behalf of the Earl of Effingham in 1773 as a hunting lodge and rural retreat. As already pointed out in Chapter 4, it was called Boston Castle to commemorate the Boston Tea Party. The Earl resigned his commission rather than fight in the ensuing American War of Independence, which he thought was unjust.

With funding from the Heritage Lottery Fund and Rotherham Metropolitan Borough Council, the castle was reopened to the public in July 2012 after years as a derelict shell. There is access to the roof and because of its lofty location (at 300 feet above sea level) there are splendid views.

Boston Castle today.

College of Jesus doorway in Boston Park.

Boston Park, comprising Boston Castle and more than 20 acres of adjoining land, was opened on 4 July 1876 on the centenary of the Declaration of American Independence. The park was designed by Henry Albiston, who became curator and lived in Boston Castle. During his time in charge the park became noted for its carpet bedding. The re-erected doorway from Rotherham's fifteenth-century College of Jesus is set in a vertical quarry face of Rotherham Red Sandstone in the park.

Coppice Woods

As the population grew and land was cleared for farming, woodlands became much scarcer and a different form of management – coppicing – became widespread. There are upwards of forty ancient coppice woods in Rotherham Metropolitan Borough, with around half of them belonging to the local authority and open to the public. An ancient wood is one that we know from written evidence to have been in existence since at least the year 1600.

Throughout the region the form of coppice management called coppice-with-standards, which combined the production of multi-stemmed coppice with that of single-stemmed timber trees, emerged as the most important form of woodland management until at least the mid-nineteenth century. In this kind of woodland management most of the trees were periodically (every fifteen to thirty years) cut down to the ground to what is called a stool, and from the stool grew multiple stems, collectively called coppice or underwood.

Some of the trees were not coppiced but were allowed to grow on to become mature single-stemmed trees, and these were the standards. The standards would normally grow through a number of coppice cycles, as the coppice rotations were known, and therefore were of various ages. In the past coppice-with-standards woods in South Yorkshire were called Springs. This is an Old English word that was used from the fifteenth to the end of the nineteenth century. There are still woods in the landscape that are called a spring, or have been in the past; for example, in a list of south Yorkshire coppices belonging to the Earl of Shrewsbury drawn up around the year 1600 Canklow Wood was called Canklowe Springe, and Wickersley Wood was called Wickersley Springe.

Coppicing.

THE DUKE OF NORFOLK'S TIMBER SALE, 1853.

FALLS HAVE BEEN SET OUT IN THE UNDERMENTIONED WOODS,
FOR WHICH
TENDERS WILL BE RECEIVED
AT THE
OFFICE OF HIS GRACE'S AGENT, CORN EXCHANGE, SHEFFIELD,
ON TUESDAY, THE 15th DAY OF FEBRUARY NEXT, AT TWO O'CLOCK.

CANKLOW WOOD, 10th FALL.

168	OAK TREES	Numbered with	Scribe Irons.
469	OAK POLES	Swatched with	Do.
30	BIRCH AND WIGGIN Do.		...	Do.	Do.	

With the BARK, TOPWOOD, and UNDERWOOD.

Handbill announcing the sale of timber, wood and bark in Canklow Wood, 1853.

Woodland Products

The uses to which the wood and timber were put were legion. The timber trees, mostly oak, were used in building projects such as timber-framed houses, barns and industrial premises such as fulling mills, forges and grinding wheels. Branches, roots and thick coppice poles were converted into charcoal for iron smelting and making blister steel. The bark of oak trees was peeled and made into a liquor for tanning leather to make the hides workable and there were tanneries throughout the area; for example, in 1710 the

Hamby's antique centre, formerly the Three Cranes Inn, High Street, Rotherham. The oldest parts of this timber-framed building date from the fifteenth century.

Internal timber work in the Three Cranes.

Whiston barn (a timber-framed building).

A charcoal maker's hut.

'Pilling' bark.

Duke of Norfolk's wood agent paid for ale when he 'let the Pilling' (i.e. the bark peeling contract) at Treeton Wood and later sold bark to what he called 'the Wath tanners'.

Woodland crafts associated with coppice woods were widely distributed. They included basketmaking, besom-making, chair-bodging, clog sole making, coopering and turnery. Besides making wooden plates, dishes, ladles and spoons, until forty years ago turners also made dolly pegs and wringer rollers, but these objects are no longer required in an age of automatic washing machines. At the time of the 1851 census living in Rotherham town were two coopers, two wood turners, a basketmaker and a wheelwright.

Identifying an Ancient Wood on the Ground

Ancient woods are often on parish boundaries or steep slopes and are typically irregular in shape and often bounded by a stone wall or bank and external ditch. They are carpeted by a ground flora referred to by historical ecologists as ancient woodland botanical indicators including such common woodland flowers as bluebell, wood anemone, yellow archangel, ramsons and wood sorrel. They are so-called because they find it difficult to colonise new sites outside ancient woodland.

DID YOU KNOW?
The medieval name for Treeton Wood was Oaken Cliff. This old name tells us something about both its composition (sessile oak) and its site (on a steep slope).

Gallery Bottom Wood, an ancient woodland in Kimberworth Park carpeted with bluebells.

Historical Timeline for Rotherham

Evidence of human beings living in the Palaeolithic period has been found in Deadman's Cave in Anston Stones Wood.

8,000–3,000 BC: Hunter-gatherer artefacts (microliths) found at the summit of Hail Mary Wood at Treeton suggest that there was a Mesolthic encampment.

A Bronze Age boat was found during extensions to Steelworks at Templeborough.

500 BC: Iron Age fortified sites survive in Canklow Wood and Scholes Coppice.
AD 54: A Roman fort was established at Templeborough in the Lower Don Valley.
1086: The manor of Rotherham was named and described in the Domesday Book.
1147: Roche Abbey was founded.
1161: The monks of Kirkstead Abbey in Lincolnshire were granted the right to dig for ironstone and make iron at Thorpe Common.
1283: In this year there was the first definite proof that Rotherham had the right to hold a market.
c. 1483: Bishop Thomas Rotherham founded the College of Jesus in the town.
1539: John Leland visited Rotherham and called it 'a reasonable large market town'.
1568: Mary, Queen of Scots, in captivity stayed for one night in Rotherham on her way to Tutbury Castle.
1637: A deer park licence was granted to Viscount Castleton at Sandbeck Park.
1643: On 2 May the local population had a battle with Cavaliers during the Civil War at Rotherham Bridge.
1730: The Rotherham Plough was patented by Joseph Foljambe.
1732: Work began on the Palladian mansion at Wentworth Woodhouse.
1745–46: Walker Brothers' foundry was established at Masbrough.
1773: The building of Boston Castle began.
1774–80: Capability Brown was redesigning Sandbeck Park.
1781: Ebenezer Elliott, the 'Corn Law Rhymer', was born in Masbrough.
1783: Beatson Clark's glassworks was established on its present site.
1790: Humphry Repton was at work redesigning the park landscape at Wentworth Woodhouse.
1823: Parkgate Iron & Steel Works was established.
1832: A cholera epidemic claimed the lives of thirty-two people in Rotherham.
1838: The first railway line reached Rotherham (from Sheffield).
1840: The Midland Railway from London was opened to Rotherham.

1841: Fifty people (forty of them children) were drowned at a boat launch at Providence Dock, Masbrough.

***c.* 1850:** The colonisation of the Lower Don Valley between Sheffield and Rotherham by the heavy steel industry began.

1851: The population of Rotherham parish was 16,822.

1865: An election riot took place in Rotherham.

1876: Boston Park opened on the centenary of the US Declaration of Independence.

1891: Edward, Prince of Wales, and Princess Alexandra opened Clifton Park.

1901: The population of Rotherham parish was 61,541.

1912: On 9 July George V and Queen Mary visited Silverwood Colliery.

1919–29: In this ten-year period Rotherham Corporation built more than 2,500 council houses.

1968: The Tinsley Viaduct on the M1 was opened.

1993: Steel Peech & Tozer Steelworks was closed and later the melting shop was reopened as Magna Science Adventure Centre.

2011: The population of Rotherham Metropolitan Borough was recorded as 257,000 in the 2011 census.

2012: The first game of football (a friendly against Barnsley) was played by Rotherham United at the New York Stadium.

2013: Maltby Main Colliery closed after working for 102 years.

Bibliography

Bennett, S. and Dodsworth, T. 'Remembered in Stone: Church Monuments in the Rotherham Area' in M. Jones (ed.) *Aspects of Rotherham: Discovering Local History, Volume 3* (Wharncliffe Publishing Limited, 1998), pp. 60–80.

Crowder, F. and Greene, D., *Rotherham: Its History, Church and Chapel on the Bridge* (S. R. Publishers, 1971).

Crowder, F., *A Walk Round Old Rotherham* (Department of Libraries, Museum and Arts, Rotherham Metropolitan Borough Council, 4th edition, 1989).

Dodsworth, T., 'The Odd Confounded Speech of Rawmarsh Lane: Aspects of the Growth of Parkgate, 1831–1891', in M. Jones (ed.) *Aspects of Rotherham: Discovering Local History, Volume 1*, (Wharncliffe Publishing Limited, 1995), pp. 175–205.

Guest, J., *Historic Notices of Rotherham*, (Robert White, 1879).

Jones, J. & Jones M., *Historic Parks and Gardens in and Around South Yorkshire* (Wharncliffe Books, 2005).

Jones, M., *Rotherham's Woodland Heritage* (Rotherwood Press, 1995).

Jones, M. (ed.), *Aspects of Rotherham: Discovering Local History, Volumes 1–3* (Wharncliffe Publishing Limited, 1995, 1996 and 1998).

Jones, M., 'Rents, Remarks and Observations: The First Marquis of Rockingham's Rent Roll Book' in M. Jones (ed.) *Aspects of Rotherham: Discovering Local History, Volume 1* (Wharncliffe Publishing Limited, 1995), pp. 113–128.

Jones, M., *Trees and Woodland in the South Yorkshire Landscape: A Natural, Economic and Social History* (Wharncliffe Books, 2012).

Jones, M., *South Yorkshire Mining Villages: the History of the Region's Coal Mining Communities* (Pen & Sword, 2017).

Lodge, T. 'Rotherham's Railway Trades: An Early Chapter in Heavy Engineering' in M. Jones (ed.) *Aspects of Rotherham: Discovering Local History, Volume 1* (Wharncliffe Publishing Limited, 1995) 241–272.

Munford, A. P., *Victorian Rotherham* (Quoin Publishing Limited, 1989).

Munford, A. P., *A History of Rotherham* (Sutton Publishing, 2000).

Munford, A. P., *Iron & Steel Town: An Industrial History of Rotherham* (Sutton Publishing Ltd, 2003).

Rogers, A., 'Deer Parks in the Maltby Area' in M. Jones (ed.) *Aspects of Rotherham, Discovering Local History, Volume 3* (Wharncliffe Publishing Limited, 1998), pp. 18–30.

Smith, A. H., *Place-names of the West Riding of Yorkshire, Part 1* (Cambridge University Press, 1961).

Smith, H., *The History of Rotherham's Roads and Transport* (Rotherham Metropolitan Council, 1992).